Impressionist
and
Modern

The art and collection of Fritz Gross

Catherine Whistler
with contributions by
John Milner and Renate Gross

Ashmolean Museum Oxford
in association with
Oxford University Press, 1990

Hatton Gallery, University of Newcastle 11 May – 9 June 1990
Ashmolean Museum, Oxford University 14 August – 21 October 1990

Text and illustrations
© The University of Oxford: Ashmolean Museum, Oxford, 1990

Ashmolean Museum Oxford
in association with Oxford University Press

British Library Cataloguing in Publication Data
Whistler, Catherine
 Impressionist and modern: the art and collection of Fritz Gross.
 1. Austrian visual arts. Gross, Fritz, 1895–1969
 2. French Graphic arts – Catalogues, indexes
 I. Title II. Ashmolean Museum
 709'.2'4

 ISBN 0-907849-97-0 (paperback)
 ISBN 0-907849-98-9 (casebound)

Cover illustration: Edgar Degas, *Dancer,* catalogue no. 13

Designed by Cole design unit, Reading
Set in Frutiger by Meridian Phototypesetting Limited
Printed and bound in Great Britain by Jolly & Barber Limited, Rugby

Preface

The idea of an exhibition of the collection of Fritz Gross was proposed to the Ashmolean Museum by Christopher Lloyd shortly before he took up the post of Keeper of the Queen's Pictures and was enthusiastically endorsed by Dr. Nicholas Penny, then Keeper of the Department of Western Art. Newcastle meanwhile had had a similar idea. Renate Gross introduced the interested parties and showed them what the Gross family possessed. She has not only been responsible for cataloguing (with the help of Judy Marshall-Purves) those works by her father which have been included in the exhibition but has also contributed much information to Dr. Catherine Whistler who has catalogued the other material, and she also provided much of the biographical data required for the introduction. Her enthusiasm, efficiency and hospitality have made the exhibition possible. We are also grateful to Adrian Eeles for his help in the planning stages. We are indebted to members of the Ashmolean Museum staff who have agreed to work in exceptional circumstances to get the catalogue and the exhibition prepared properly and on time: Michael Dudley, Noelle Brown, Vera Magyar, Judith Chantry, and Barry Cottrell. Two volunteers working in the Ashmolean, Selina Ayers and Linda Calcutt, should also be thanked.

Christopher White
Director, The Ashmolean Museum

John Milner
Head of the Fine Art Department and Director of the Hatton Gallery,
University of Newcastle-upon-Tyne

Introduction: The Life and Work of Fritz Gross

Fritz Gross was born at Bielitz in the Austro-Hungarian Empire on 24 February 1895, the son of the industrialist Max Gross. His mother's family were brewers. His grandfather, Markus Strassman, was a philanthropist who built the synagogue and cemetery for his home town. As a young man in Vienna his interests soon evolved towards architecture which was to dominate his professional career throughout his life. His studies at the Technische Hochschule in Vienna were interrupted by the War. Called up for the Austrian army, Gross was engaged in building funiculars and served on the Italian front. Nevertheless study under Adolf Loos had brought him into close contact with the latest thinking in Austrian architecture at a crucial moment of its development, for it was Loos who led the movement away from the flourishing decoration of the Jugendstil, or Art Nouveau, which had found such spectacular expression in Vienna in the architecture of Otto Wagner and others, in the lavish and expressive decorations of Gustav Klimt, Koloman Moser and many other artists and designers associated with the Vienna Secession. The firm link that this established between art and design and between painting and architecture is reflected in Gross's twin preoccupations. He followed his architectural training by studying painting under the Polish artists Falat, director of the Cracow Academy, and Glasner. On the other hand Gross did not become a decorator in the tradition of Klimt. Of a younger generation he was attracted instead to the severity of Adolf Loos's unadorned walls at a time when Loos was at the peak of his career. For Loos decoration was a sin and its superficial quality was rejected in favour of diverse materials well worked and assembled together in the simplest way. Curiously this could lead to effects that were still lavish, comfortable and welcoming and Loos's design for the American Bar in Vienna made this clear. Plain walls, leather, rich woods, mirror and metal combined discipline and simplicity of form, interiors that were practical and useful. Gross studied architecture at a moment of change in a European city that remained a centre for advanced architectural experiment with an international impact. His training can only have impressed upon Gross the advantages and possibilities of an open-minded internationalism in architecture and design.

In painting the sense of decoration so evident in Vienna during the period 1895–1914, the period of Gross's childhood, had increasingly been employed to expressive effect. The sensually symbolic decorations of Klimt led to the fiercely exaggerated decorative approach of Schiele. The concept of Expressionism was growing and finding focus in the Berlin exhibition-organising group and periodical *Der Sturm*. Amongst its Austrian adherents the young

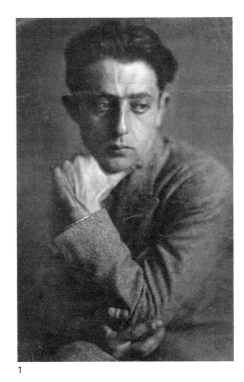

1

1 Fritz Gross in Vienna, 1929

Oskar Kokoschka was another artist who, having learned much from the example of Klimt, evolved his means towards expressionist ends. Gross, in a sense, was the heir to these developments which, by 1914, were thoroughly international involving artists from many countries and adopting diverse approaches in their exhibitions, from the Cubism of Picasso, Braque and Delaunay to the fantastic paintings of Chagall or the non-representational art of Kandinsky. Gross however was committed to painting people as he saw them, active and responding to each other, yet there are traces in his work and that of certain contemporaries, in particular Georg Mayer-Marton, of the heritage of these years. Gross was also to respond to compatible features of painting studied in Paris, attracted to the human tenderness which survives in the paintings of Renoir, Bonnard or even Pascin.

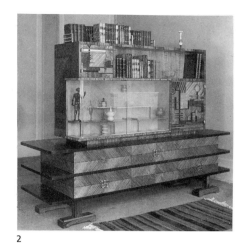

2

Gross frequently exhibited as a painter between the Wars. He exhibited as a guest at the 1921 Hagenbund modern art exhibiting society in Vienna of which he subsequently became a committee member, remaining active in the Hagenbund from 1924 to 1935. He exhibited regularly in Vienna, Berlin, Prague, Barcelona and elsewhere including group exhibitions at the Galerie Würtle in Vienna in 1921, and by 1924 he was showing works very widely in group exhibitions at Budapest, Pressburg, Prague, Munich, Nuremberg and Berlin. In these displays Gross was frequently exhibiting in the most distinguished and adventurous company. In 1927, for example he showed three pastels at the Hagenbund exhibition, of which he was now a committee member, and it is indicative of his awareness of contemporary art to note the inclusion of works by Braque, Chagall, Delaunay, Derain, Van Dongen, Dufy, Gris, Gromaire, Laurencin, Le Fauconnier, Matisse, Pascin, Picasso, Rouault, de Segonzac and Vlaminck.

Clearly his discerning eye was at work in 1927. His work also began to be reproduced in the periodical *Menorah* in 1925 and recognition as a painter was beginning. In 1926 he married Franzi Wiener in Vienna and alongside his painting he began to gain increasing recognition as an architect and designer. More periodicals reproduced his work: *Deutsche Kunst und Dekoration* in 1927 and in the following year A. Weixlgärtner devoted an article to Gross in the Viennese journal *Die Graphischen Künste*. He also appeared again in *Deutsche Kunst und Dekoration* and in the *Jahrbuch der Wiener Gesellschaft* that year.

In architecture 1928 proved a crucial year for his development and recognition. Well aware of the evolving international style in architecture in the work not only of Loos but of Le Corbusier, Gropius, Mies van der Rohe and others, Gross emerged as a pioneer designer of the open-plan interior, the Einwohnraum, in which continuously flowing interior space is subdivided by double-sided furniture and other devices, economically articulating the activities of a house or office, without the physical enclosure of separate rooms. Storage, living room, bedroom were all brought together in an efficient,

2 A piece of dual-function furniture from the 'Einwohnraum', 1928

comfortable and stylish interior. This became an immensely influential concept in the design of interiors from the late 1920s through into the 1950s and survives, particularly in office interiors, into the present day. That Gross was amongst its pioneers is undeniable. It remained a central tenet of his interior design from 1928 onwards and was readily adaptable to the exhibition and display functions of much of his later architectural design. He first exhibited open-plan designs at the Kunsthistorisches Museum in Vienna in 1929.

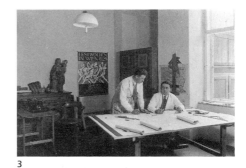

The combined talents of architect, designer and painter flourished in Gross simultaneously. He was busy and fruitful over the next decade, exhibiting with the Manes Society in Prague in 1929 and discussed increasingly in magazines devoted to architecture and design, *Innen-Dekoration* in 1929 and 1933, *Deutsche Kunst und Dekoration* (1930), *Die Kunst* (1931), *L'Architecte* (1933), and he was increasingly acknowledged in books and almanacs including J. Hoffmann *Moderne Bauformen,* Stuttgart (1930, 1932), and N. Klang's *Die Geistige Elite Österreichs,* Vienna 1936. Gross shared with Gropius, Corbusier, numerous Russian architects, and also Jack Pritchard in England, the concept of the minimal dwelling, specialized design for the one-room flat or bedsitter that was at once stylish, comfortable and practical for the city-dweller. Gross designed not only the division of space but also the furniture to occupy it and he merits particular recognition as a furniture designer, who combined practical design with fine craftsmanship revealing a deep respect for the materials employed particularly wood of various kinds inlaid in intricate designs in his furniture. This is as evident in the mobile dressing table of 1936 as in the marvellously spacious room provided for the Grosser Brockhaus display of 1937. Featuring large plate glass windows, simple wooden panels — ceiling included — and open-structure furniture of bent wood, it is characteristic of his love of elegance, fluid space and freedom from constraint, a rich, human and highly usable design which is well resolved and severely edited, without clutter or enclosure, permitting the natural space and light of the outdoor natural world to penetrate the room.

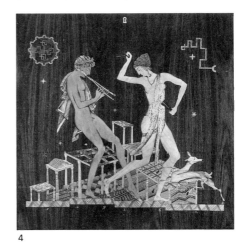

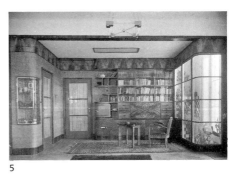

Tragically, the increasingly violent politics of Germany and Austria in the late 1930s threatened the safety of Gross, who was a Jew, and the rhetoric of nationalism was antagonistic to the openly internationalist intelligence manifest in his architecture. The invitation received from the President of the Royal Institute of British Architects in 1938 to visit London to exhibit and attend an international conference was interpreted by Gross, as it was by Gropius, Breuer and others, as an invitation to escape. This British manoeuvre deserves study in itself, for it was to have a profound effect upon British and American architecture, stretching beyond the humanitarian purpose and professional recognition that inspired it. Gross emigrated to England in 1938, exhibiting at the RIBA the same year and finding employment with a firm of interior designers. It was a move which, in all probability, saved his life. It also brought his multiple talents to Britain where Gross became immediately active to the evident benefit

3 Fritz Gross (right) with a colleague in his Viennese studio, c. 1930
4 Detail of an inlaid wood design from a cabinet, Vienna, early 1930s. Over ten varieties of wood are employed
5 A panelled hallway with built-in units and table and chair, Vienna, 1936

of his host country. He was first employed to teach art and architecture at the Bedford High School during the war years (1941 – 46) where his wide knowledge, experience and enthusiasm were recognised as invaluable. He lectured in extra-mural studies at the Bedford School and at the Physical Training College in Bedford. During this period of suspended architectural work he turned with fervour to painting, especially portraits, as if to assert, in the bleakest of times, the importance to him of people as individuals.

In 1947 he returned to London and architecture, designing exhibitions, displays, hotels and showrooms. He also began to exhibit as an artist in England. Included in *Artists of Fame and Promise* at the Leicester Galleries in 1946 in London, he found himself in a very different artistic milieu alongside Moynihan, Ruskin Spear, Gowing, Paul Nash, Piper and Dame Ethel Walker. His one-man exhibition held at the Bedford School moved to the Leicester Galleries in 1946 and in the same year he became a British Subject. By 1949 he was a Fellow of the Royal Society of Arts and was soon to become a Fellow of the Society of Industrial Artists.

Architecture, furniture design and painting continued to evolve together and recognition in Britain steadily grew. The 'young artist of whom we shall be glad to hear more' mentioned in the *Times* (20 July 1945) became increasingly busy. In 1947 he was lecturing at the Hammersmith School of Architecture and in 1949 he held a two-man show (with Jim Wyllie) at the Marlborough Gallery, London, whose interior he was also to design.

It was during these years that Gross began the spectacular collection of which this exhibition reveals a part. The collection is both diverse and discerning. It is said that a collection reveals the collector's taste. In the case of Fritz Gross this is true in an unusual and impressive sense. From Egyptian and Etruscan to Greek and Roman glass and terracotta, from Rodin to Zadkine, from drawings by Seurat to paintings by Monticelli, from Degas to Picasso or Modigliani, there is in the collection of Fritz Gross an insatiable enthusiasm and excitement linked with a rare visual sense. To wrest coherence from such a collection is part of his achievement for his possessions do indeed point to the man. But this is not all, magnificent though this achievement is, for Fritz Gross was active in many fields beyond collecting. Collecting for him was no mere accumulation of rare objects, it was in fact voracious enthusiasm, a need to rescue, conserve and keep art works that are alive with creative ingenuity, talent and invention.

These are precisely the characteristics of his own creative drive which refused to be narrowly specialized and which led him to the fullest professional involvement with architectural and interior design, with painting and exhibition groups and with teaching as well as collecting. All of these activities were evident signs of his own creativity. Such fruitful enthusiasm was unstoppable.

The present exhibition reveals only two aspects of this multifaceted man. It combines a part of his collection with a selection

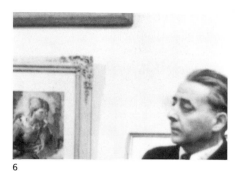
6

6 Fritz Gross at an exhibition of his work at the Bedford School, 1946

of his own paintings and graphic work. Justice cannot be done to his extensive collections of sculpture, his designs for buildings, for exhibition displays, for intricately inlaid and ingenious furniture, and of course all of his teaching and family life are missing. An exhibition is not a biography. Yet in balancing the paintings and pastels of Fritz Gross against part of his collection, there is an opportunity to make revealing comparisons. For example, it is at once clear that Fritz Gross was an individual, genuine and talented artist whose works were by no means simply derivative of the artists whom he admired. As a practising artist Fritz Gross was not overwhelmed by the quality of the work that he owned. On the other hand there is a link; for the eye which painted the pictures exhibited the same discerning vision when acquiring works by Cézanne, Derain, Kandinsky, Sickert, Beardsley, Munch and many others. This exhibition provides a rare opportunity to see the collection through the eyes of the painter.

The works by Gross are intimate and above all humane. They focus almost exclusively on people, frequently on relationships of tenderness. Ambitiously he addressed himself to great traditions in painting – of which the standing female nude is only one example – and he certainly did not work in isolation as his early involvement with important exhibition groups makes clear. Nor did he abandon his fascination with people for intellectual or abstract theories of art. Technically adventurous, Fritz Gross the painter evolved his own means independent of much that fashionable art dictated or that his collection included.

Après le bain, a late Renoir, was purchased from the Marlborough Gallery, London, in 1949. It confirmed French late nineteenth-century art as the core of his collection. He bought with discernment showing tenacity in pursuit of his prey and a brilliant eye for quality. Often travelling widely to acquire a single drawing, he nevertheless sought a realistic price for only in this way could his collection develop to the ambitious level of distinction that he achieved. On these occasions his wife was a frequent adviser in assessing just how far to go, balancing what could be afforded against the possibility of purchase.

Major purchases followed in the 1950s, particularly in 1954 when Gross acquired works by Signac, Modigliani, Camille Pissarro, the beautiful Degas drawing and a late figure study by Gauguin. That year he bought lithographs by Toulouse-Lautrec, significant acquisitions as Lautrec was to become a passion for Gross, leading to the central achievement of his collection and distinguishing Gross as an authority in this field with one of the major collections of Lautrec in private hands. In the present exhibition the blue pencil *Head of a woman* was acquired in 1956 and his drawing of *Henri Rochefort Luçay* in 1958. Purchases of Lautrec followed whenever the opportunity arose in spite of rising prices. Lautrec's crayon drawing *Les Valseuses* was bought in 1964 and *Souper à Londres* the following year. Lautrec's ink study for *Pourquoi pas?* was purchased in the last year of Fritz Gross's life.

The determined enthusiasm, acumen, connoisseurship and

knowledge required were complemented by the artist's eye for human life, shrewd and occasionally ruthless, evident in the art of Lautrec and evident with equal sympathy in a different way in the pastels and drawings of Fritz Gross. Whilst it would be wrong to suggest a direct influence, this perhaps demonstrates the sympathetic combining of the artist's outlook with the taste of the collector.

The sardonic observation of human behaviour can be seen elsewhere in the collection, in works by Daumier, Forain and Sickert. On the other hand, Gross would have rejected such a categorization and rightly for he rapidly expanded the scope of his collection from its early days to include important drawings by Courbet, Gauguin, Degas, Cézanne and Seurat. Alongside these developments he acquired sculpture and an expert and extensive collection of prints including Manet, Henri-Edmond Cross, Camille Pissarro, Signac, Munch and many others including Kandinsky and Rouault amongst the twentieth-century works. An etching after Modigliani bought in 1954 was followed three years later by the purchase of an elegant and sculptural drawing of great refinement. The prints by Picasso were complemented by a rapid and lively drawing of Apollinaire and an ink drawing by Picasso, *Femme et l'artiste* bought in 1960 and executed only a few years earlier.

Gross was still developing his collection at the time of his death, having lost nothing of his shewdness, tenacity or determination. He is even now remembered by one dealer as 'a careful and erudite buyer. He refused to show interest in any picture unless the price was so low that it hurt and even then he bargained.' It was the collection which derived benefit from this business acumen. It could not have flourished as it did without the firmest control. It had arisen with the growth of his architectural practice in the 1950s. It was a passion to the end of his life.

The 1950s saw his architectural practice increase as the country's financial recovery from war slowly began to gather pace. His concentration upon small scale projects, office interiors and exhibition displays should not be underestimated. The optimism which informed design at the Festival of Britain led to the evolution of the exhibition display and showroom in particular as vehicles for new and adventurous design, an arena in which inventiveness and new ideas could flourish and readily find public outlet. It was an architectural forum with special significance bearing comparison with the architectural displays, exhibition stands, model dwellings and design fairs of crucial importance to development in architecture and design throughout Europe in the 1920s and 1930s, displays to which Gross had himself contributed significantly particularly as an innovative interior designer. Here was a new and comparable opportunity. Gross seized it with tireless enthusiasm producing six or seven exhibition displays regularly each year, as a seed bed of architectural ideas which developed naturally into adventurous and more permanent form in his numerous office and showroom projects. These smaller projects occupied the full range of Gross's

abilities as a designer. They exemplified his concept of the open-plan interior, they incorporated his furniture and they led into architecture that was inventive, original and altogether more substantial.

1950 saw Gross design the foyer of the new mill for Haworth and Company at Salford incorporating life-size stylized reliefs by Trevor Tennant. His designs were discussed in British periodicals including *The Architect's Journal* (1953), the *Daily Mail Ideal Home Book* (1953) and the Studio Year Book *Decorative Art* in 1956–57, 1957–58 and 1958–59. In addition the *Architectural Review* focussed upon several of the commissioned interiors which incorporated display with business offices.

Six of these were featured in the *Architectural Review* in September 1954 (vol. 116, no. 693, pp. 195–198). They reveal an architect of great sophistication adapting the lessons of the 1920s and 1930s to the post-war era. The Marine Engineering showrooms at Duke Street, London, for example, had to combine the display of engines with the functioning of the firm's head office. The impressive foyer is a dynamic and flowing space articulated by sculptural forms, natural materials and a raised area, combining elements of constructivism in structure, lettering and photographic panels with elegantly sparse leather and bent wood furniture of more organic shapes. Typically Gross used fine woods to bring out these qualities of texture, grain and colour. Here the raised stage area, for example, containing settee, table and chairs, was surrounded by a shelving system of abura and sycamore.

The showrooms for an engineering firm in Newgate Street, near St. Paul's, posed a similar challenge but on a long and awkward site, divided rhythmically by Gross using curved sales desks along its lower hall overlooked by a raised showroom area well lit by tall windows with venetian blinds. Tall supporting columns are stripped of all decoration and the irregularities of the walls straightened out by panelling to provide built-in storage space. The smooth flat wall surfaces which resulted were panelled in wood relieved by cantilevered lamps, plants, lettering and panels of photographs and diagrams. The interior was a dramatic use of open-plan space which clearly separated and articulated the activities of the office whilst providing opportunities also for display, demonstration and information, characteristics equally evident in the Salford mill offices using tall rectangles of glass bricks and relief sculptures by Trevor Tennant set into the panelling of squares of wood. Similar features determine his Marine Engineering exhibition pavilion with circular windows evocative of shipping, and the offices of a publicity agency with numerous display panels. Plants everywhere act as a natural foil to machinery and repetition is turned to pattern in the wall panels, window forms, winged chairs and L-shaped curvilinear tables.

The *Architectural Review* again illustrated designs by Gross in 1957 (vol. 121, no. 725, pp. 459–460, and vol. 122, no. 731, p. 422) in a showroom in Old Street for Ferranti and a Garden Centre at 95 Wigmore Street. These adventurous designs both employed fins

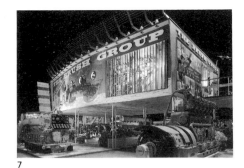

7

7 The Brush Group, marine engineering exhibition, 1953, designed by Fritz Gross

(vertical wooden struts making a tall open work screen) through which plants grew. Again there were photographic murals and large lettering used decoratively. The split level of the Old Street showroom permitted televisions to be displayed amidst a sense of occasion and drama, whilst the Garden Centre for Fisons in Wigmore Street was visible from the street and designed to appear as dramatic outside as it was from within. Gross was able to respond in detail to his clients' requirements, structural, functional and promotional. The result is practical, elegant, encouraging and imaginative.

Yet Fritz Gross the consummate professional architect occupied but one part of his creative personality. Painting and collecting, together with a happy and busy family life were occupations of great importance too. His house survives as a testament to his unstoppable, indefatigable enthusiasm. There is nothing dry, academic or overbearing in any of this. Much of his furniture is designed by himself and exquisitely inlaid with geometric designs in wood. His domestic designs extended to chairs, tables and trolleys as well as the design of locks, handles, hinges and even book jackets, jewellery and drinking glasses. This setting, filled with his own paintings and his astonishing collection, denotes a remarkable personality. He lived expansively, uniting two or three careers in one.

Fritz Gross, Member of the Central Association of Austrian Architects, FSIA, FRSA, was awarded the Freedom of the City of London in June 1967 for his services to architecture. He made a last visit to Paris in June 1969 and he died suddenly after a few days' illness on 18 August 1969 at the age of 74.

'He refused to specialize,' wrote his friend George Fejer in *The Designer* in the following October, 'to be put into a neat pigeon-hole, remaining active on the whole sector of creative arts.'

The *Times* in October 1949, reviewing his exhibition at the Marlborough Gallery in London noted the 'luxurious appearance' of his painting combining 'sustained design' with paint that is 'varied and opulent, sometimes with a jewelled brilliance of colour.' In such works the sumptuous finish of Monticelli and the resonant colour of Cézanne are recalled. Yet Gross avoided ready-made solutions, working by preference with vigour and independence, crossing with ease the boundaries between grandiose compositions of anonymous and monumental figures and the intimate observation of the people around him. These smaller works, usually in watercolour, pastel and ink, combine elements of drawing and painting to capture the fleeting impression. Their rapidity of execution may obscure their achievement for they are not slight works. The *Study for Mother and child* of 1960 is an example (No. 93). There is nothing inert or lifeless in this study. Its fluidity of execution suggests speed but it comprises also a meticulous control of his means. The loose independence of line and colour, of ink over pastel, permits the suggestion of both definition and atmosphere. Not only do the mother's arms embrace her child, drawn in fluent lines, but the soft pastel of her body embraces in its darker tone the glowing form of the child. This requires both spontaneity

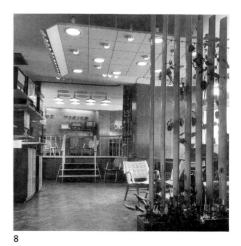

8

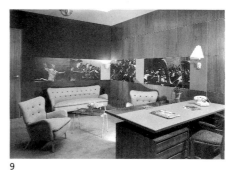

9

8 Ferranti Ltd showrooms, Old Street, London, 1957, designed by Fritz Gross
9 Manager's office, Ferranti Ltd. Mahogany-panelled office with photographic murals, designed by Fritz Gross, 1957

and experience. It is an achievement also in another sense that is central to the art of Fritz Gross. In this study lies all the potential of a painting, it is a means to an end that reveals his working process. In this ambition and potential Gross is remarkable. Because of it he is able to carry his swift, skilled and tender observation of individuals on to the level of a broader depiction of maternal protection for the naked, glowing child. This is an emotionally expressive art of great refinement in which Gross's knowledge and experience of many artists from Renoir to Picasso and even perhaps Henry Moore, enrich his vision without affectation, or the least loss of originality, power or immediacy.

His designs, his paintings and his collections reflect the man and continue his reputation. What emerges is however more than the reputation indicated by lists of exhibitions – his memorial exhibition at the O'Hana Gallery, London, in 1970, in 'Those who left us', *Die uns verliessen* at the Österreichische Galerie at the Upper Belvedere, Vienna in 1980, in *Austrian and German Art* at the Goethe Institute, London, in 1980, or his one-man exhibition at the Peithner-Lichtenfels Galerie, Vienna in 1982.

What echoes through all of his activities, the sum of his painting, architecture and collecting is his personality as much as his taste, skill or professionalism. For those of us who missed him this exhibition is an opportunity to glimpse an irrepressible artist. For those who knew him, I hope that it provides a new token of growing esteem for the personality that they will recognize at once.

John Milner
October 1989

10

10 Fritz Gross sketching in a Paris café, mid-1960s

50 Paul Signac
The bridge at Montauban

40 Camille Pissarro
Église et ferme, Eragny (Church and farm, Eragny)

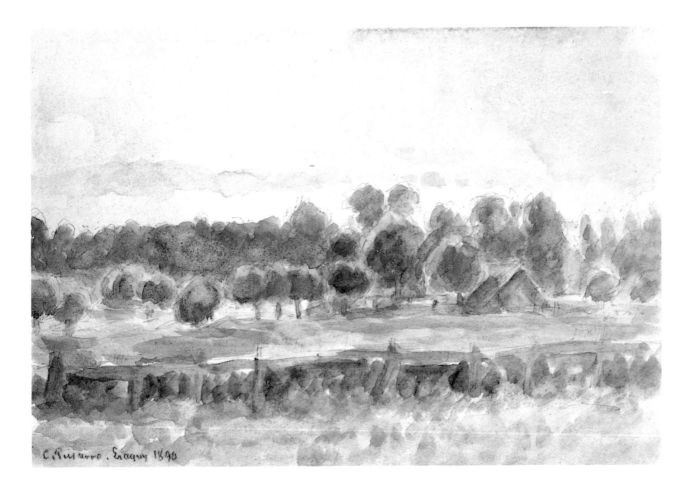

39 Camille Pissarro
Landscape at Eragny

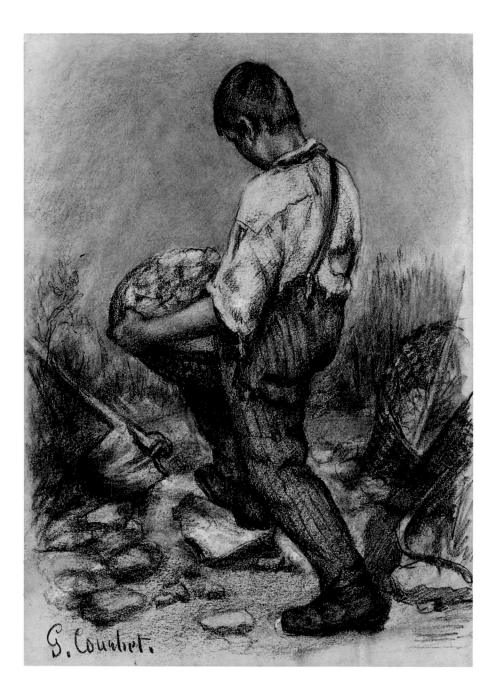

8 Gustave Courbet
A young stonebreaker

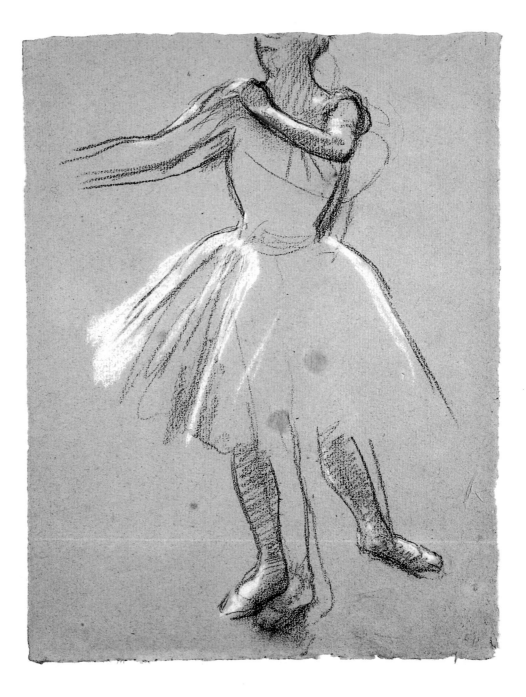

13 Edgar Degas
Ballet dancer

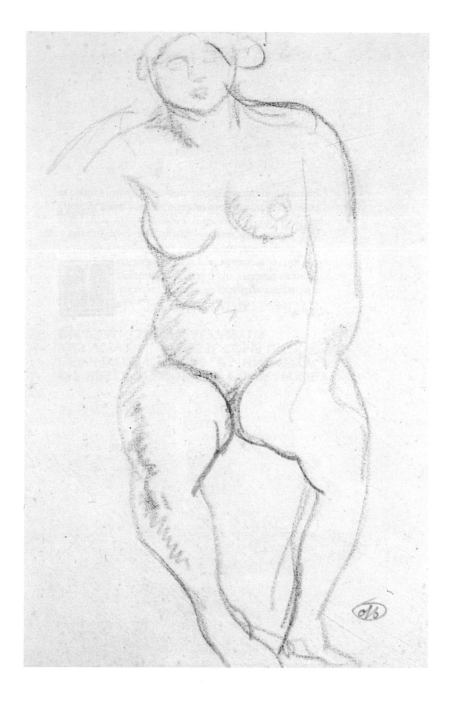

26 Aristide Maillol
Seated female nude

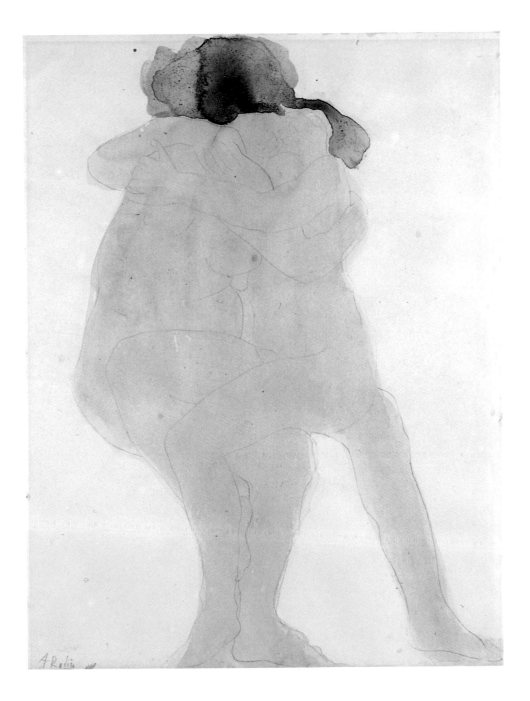

44 Auguste Rodin
The embrace

61 Henri de Toulouse-Lautrec
Yvette Guilbert

59 Henri de Toulouse-Lautrec
Les Valseuses (The waltzers)

34 Pablo Picasso
Portrait of Apollinaire

15 André Derain
Pantagruel

7 Marc Chagall
How the women kept a secret

29 Amedeo Modigliani
Male nude

19 Paul Gauguin
Study for 'Tahitian women on the beach'

24 Eva Gonzales
Portrait of Jeanne Gonzales

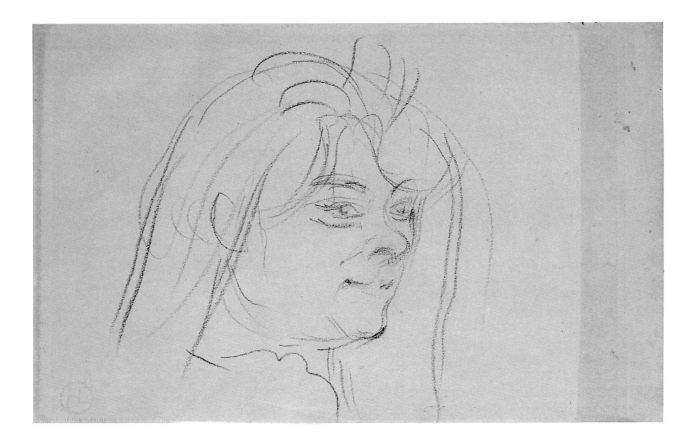

60 Henri de Toulouse-Lautrec
Tête de femme à la chevelure defaite (Head of a woman
with untidy hair)

31

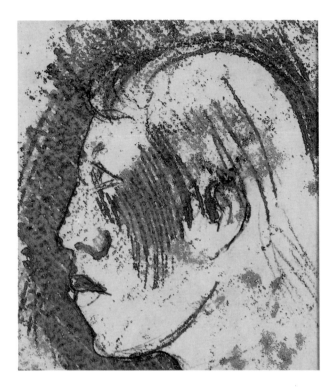 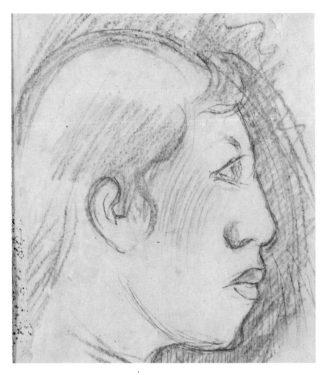

23 Paul Gauguin
Head of a Marquesan girl (*recto* and *verso)*

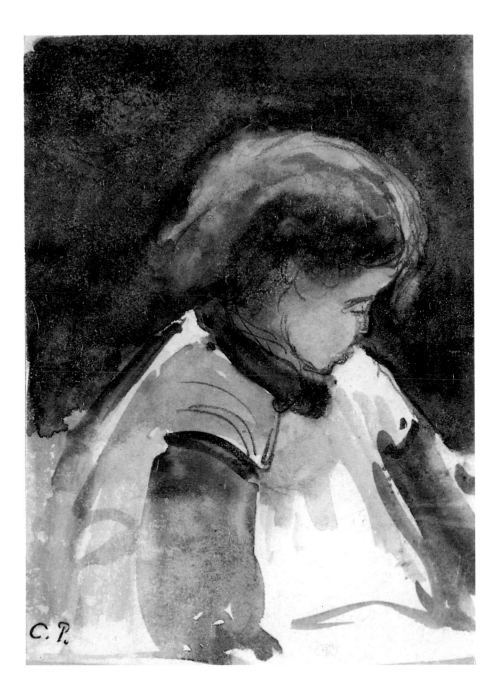

38 Camille Pissarro
The artist's daughter, Minette

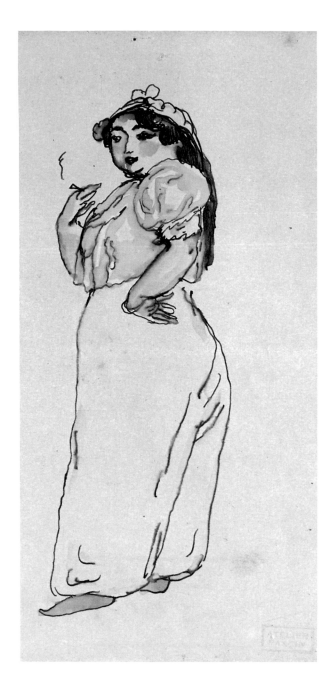

33 Jules Pascin
Turkish girl

41 Pierre-Auguste Renoir
Après le bain (Bather)

14 André Derain
Bathers

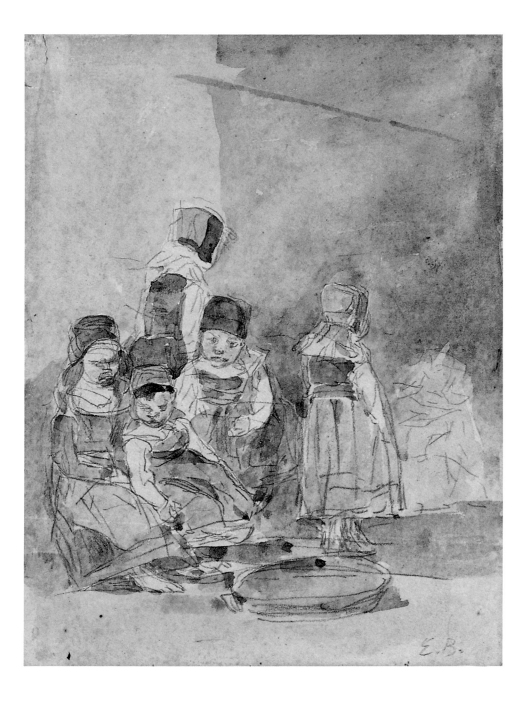

4 Eugène Boudin
Interior with Breton children

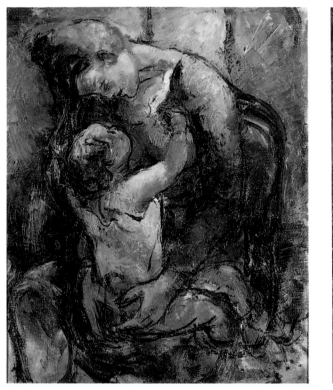

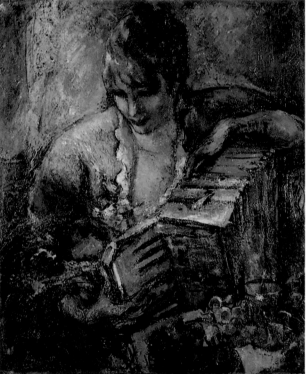

94 Fritz Gross
Mother and child

80 Fritz Gross
Girl with accordion

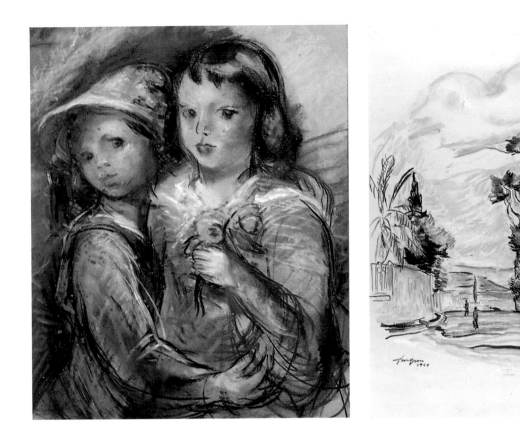

74 Fritz Gross
Two young friends

103 Fritz Gross
Cap Martin

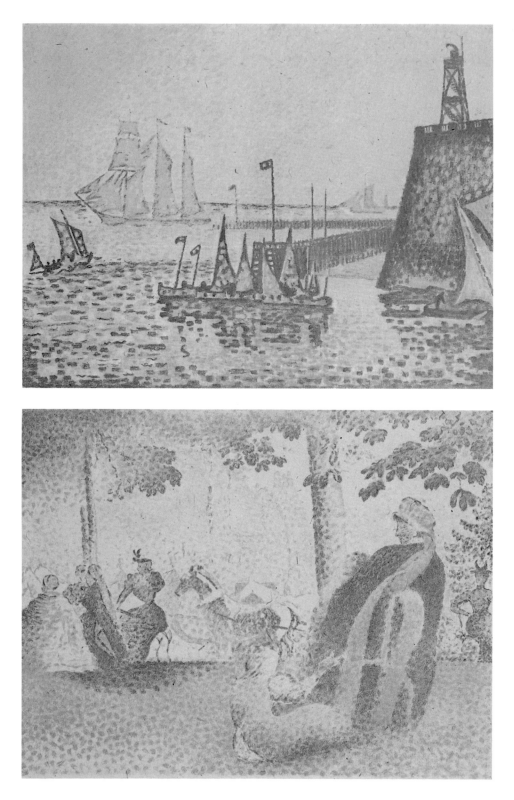

51 Paul Signac
 Le Soir (Evening)

9 Henri-Edmond Cross
 Les Champs-Elysées

A note on the catalogue

Dimensions are given in centimetres or millimetres, height before width.
Where it has not been possible to examine the whole sheet, the dimensions of the visible area of the print or drawing inside its frame or mount are given, with the phrase 'inside of aperture'.

List of works frequently cited

Boston 1961.
Boston, Museum of Fine Arts, and Harvard College Library Department of Printing and Graphic Arts, 1961 *The Artist and the Book 1860–1960* by E.M. Garvey.

Delteil.
L. Delteil *Le peintre-graveur illustré* Paris, 1907-26. Vol. X and XI, *Henri de Toulouse-Lautrec* 1920. Vol. XVII *Camille Pissarro, Alfred Sisley, Pierre-Auguste Renoir* 1923.

Dortu.
M.G. Dortu *Toulouse-Lautrec et son oeuvre* 6 vols, New York, 1971.

Guérin.
M. Guérin *L'Oeuvre gravé de Gauguin* Paris, 1927.

Ingelheim 1968.
Ingelheim am Rhein, 1968 *Henri de Toulouse-Lautrec.*

Joachim.
H. Joachim *French drawings and sketchbooks of the nineteenth century* 2 vols, The Art Institute of Chicago 1978–79.

Joachim, Kornfeld and Mongan.
H. Joachim, E.W. Kornfeld and E. Mongan *Paul Gauguin: Catalogue raisonné of his Prints* Berne, 1988.

Johnson.
U. Johnson *Ambroise Vollard Editeur* 2nd ed. New York, Museum of Modern Art, 1977.

Lugt.
F. Lugt *Marques de Collections (Dessins-Estampes)* Amsterdam, 1921, and *Supplément* The Hague, 1956.

Maison.
K. Maison *Honoré Daumier. A Catalogue Raisonné of the Paintings, Watercolours, and Drawings* 2 vols, London, 1967.

Munich 1960.
Munich, Haus der Kunst, 1960 *Paul Gauguin.*

Paris 1960.
Paris, Galerie Charpentier, 1960 *Cent oeuvres de Gauguin.*

P & V.
L. Pissarro and L. Venturi *Camille Pissarro: Son art – son oeuvre* 2 vols, Paris, 1939.

Wildenstein.
G. Wildenstein *Gauguin* Paris, 1964.

Wittrock.
W. Wittrock, *Toulouse-Lautrec: The Complete Prints* 2 vols, London, 1985.

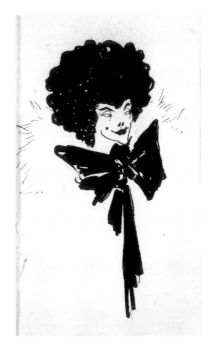

1 Aubrey Beardsley (1872–1898)
The velvet bow
Pen and indian ink over indications in pencil on white paper
85 × 50 mm (inside of aperture)
Provenance: Purchased from Agnew & Co., London, before
1967
Exhibitions: New York, Gallery of Modern Art, 1967 *Aubrey
Beardsley* No. 125
Literature: B. Reade *Beardsley* London, 1967, cat. 231 and pl. 230

This drawing was for a vignette on p. 187 of *Bons Mots of Charles Lamb and Douglas Jerrold* edited by Walter Jerrold and published by J.M. Dent in 1893; it appeared again on p. 153 of *Bons Mots of Samuel Foote and Theodore Hook* also edited by Jerrold and published by Dent in 1894. One other volume was published in the series in 1893, also illustrated by Beardsley, and in several cases there are repetitions of vignettes and ornamental devices from the first book.

Beardsley's chance meeting with John Dent in a bookshop in 1892 was to launch his career: he accepted the major commission of providing both illustrations and all of the graphic ornament of chapter headings, borders and vignettes for Malory's *Le Morte d'Arthur,* which made his reputation. At the same time he worked on the quirky, witty, grotesque and sometimes downright odd illustrations for the three little *Bons Mots* volumes. He visited Paris in mid-1893 and the impact of contemporary French art – especially Vallotton and Toulouse-Lautrec – is apparent in his work. His vocabulary embraces monsters, goblins, satyrs and masked or disturbingly foetus-like caricature figures, but also has a light-hearted side with clowns, Commedia dell'Arte or fancy-dress figures, and others reminiscent of fashion drawings. Like most of Beardsley's work, this drawing was made with the technique of line-block reproduction in mind. This meant drawing in terms of lines, dots and dashes or flat areas of the same tone value – intermediate tones could only be suggested by dots or lines laid closely together. The artist however turned these restrictions to his advantage. This vivacious sketch displays a change of mind in its execution: the curly head was originally intended to be much tighter and smaller, as is revealed by the different, more dense and matt quality of the ink. The area of the hair was greatly enlarged and more loosely worked, as was the large bow. This revision gave the drawing an expansiveness and verve, and a far bolder effect.

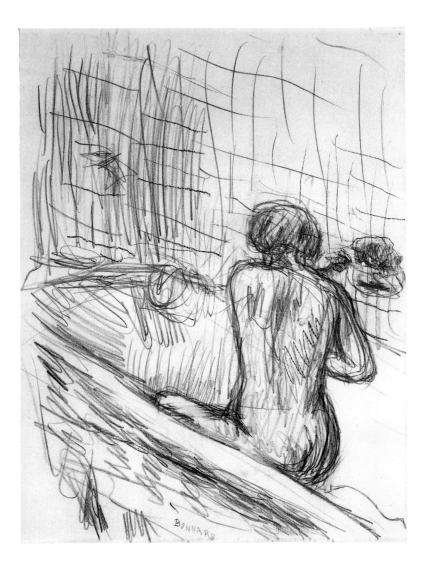

2 Pierre Bonnard (1867–1947)
 Femme au bain (Nude in the bath)
Pencil on faded white paper, laid down. Signed below centre,
 Bonnard. There are two pinholes in the top corners
282 × 225 mm
Provenance: Purchased from the O'Hana Gallery, London, July
 1956, £120

This vigorous pencil drawing has a painterly feel, with great attention paid to the masses of light and shade. The woman's body, initially outlined (and the contour of her right leg, on which she kneels, has been left at that stage), is then freely worked and re-worked with the contours firmly emphasised, while the shape and shadowing of the bathtub against the tiled wall, itself catching the light above the woman's head, is effectively captured. One might have expected such a tonal study to have been executed in a softer medium like charcoal or black chalk. However Bonnard drew constantly with whatever was to hand, and his wife Marthe, who bathed obsessively, was his model. His drawings and paintings of women in the bath date from around 1924 onwards. This drawing is not directly related to any of Bonnard's paintings, although a picture of a kneeling nude in the bath seen from almost the same angle may be connected (J.H. Dauberville *Bonnard* Paris 1965–74, III, 1276). It forms part of his large output of rapid, spontaneous sketches of intimate domestic scenes.

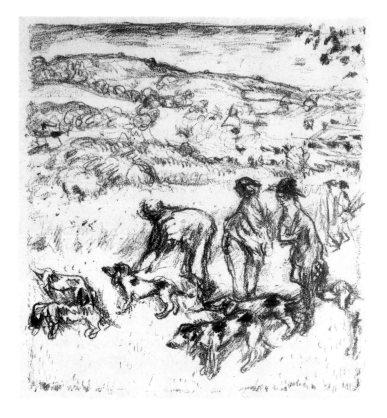

3　Pierre Bonnard
　　Le Lacher des chiens (The unleashing of the dogs)
Crayon lithograph, printed in black ink on Chine volant (a thin
　　greyish handmade paper). Artist's proof. Inscribed on the
　　verso in pencil *Bonnard/Daphnis et Chloé/épreuve chine*
151 × 138 mm (image), 328 × 257 mm (sheet size; folded at
　　lower edge)
Provenance: Purchased London, Mercury Gallery, Sale 12th
　　February 1966, No. 39, £30
Literature: F. Bouvet *Bonnard the complete graphic work* New
　　York, 1981, No. 76b. See also Boston 1961, No. 28, and
　　Johnson No. 168

This was conceived as one of the illustrations to Ambroise Vollard's
publication in 1902 of *Les Pastorales* or *Daphnis et Chloé* by
Longus Sophista, a Greek writer who lived between the 1st and
4th centuries. Bonnard provided 151 lithographic designs, which
were printed on a handpress by the master printer Auguste Clot,
and the stones were effaced afterwards. Only 250 editions were
printed. This lithograph was not in fact included in the book, and
is one of six variants of different subjects which were printed in
separate editions. Fifty prints were made of *Le Lacher des chiens*
on loose-leaf China or Japanese paper, in blue, black or bistre; a
very small number of proofs were also made, some like this one
signed in pencil.

　　Daphnis et Chloé is a mildly erotic pastoral novel of two

shepherds brought up in the wilds who slowly discover the joys
of love; it was certainly popular as a subject for illustration in this
century – both Maillol and Chagall produced designs for other
editions. This episode occurs in Book II, 13, where the young men
of Methymna come into the fields to hunt (here unleashing their
dogs) and later attack Daphnis for a misdemeanour he did not
commit.

　　Around 1895 Vollard began to publish original artists'
prints, and one of his earliest projects was an album of twelve
prints by Bonnard of scenes of Parisian life. Vollard soon moved
on to the commissioning of fine illustrated books on high-quality
handmade paper, often asking artists to choose the works they
desired to illustrate. (Chagall, Picasso and Rouault were amongst
the artists who worked for him: see Nos. 7 and 45 below.) His
first book, published in 1900, was Verlaine's *Parallèlement* with
109 lithographs and nine wood-engravings by Bonnard. *Daphnis
et Chloé* followed, with its illustrations, faithful though they
were to the text, displaying a sketchiness and spontaneity, and a
lightness of touch unusual in book-illustration at the time. The
book did not sell very well, possibly because the public was
accustomed to the boldness and precision, as well as to the
realism, of wood-engravings. Bonnard went on to provide
numerous designs for other publishers, and collaborated again
with Vollard on the major project of *La Vie de Sainte Monique*
published in 1930.

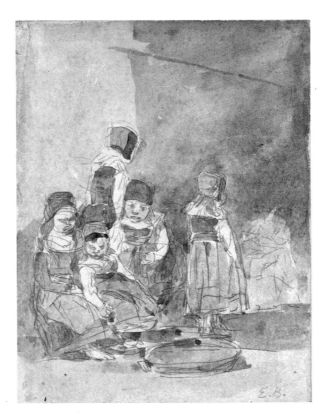

4 Eugène Boudin (1824–1898)
 Interior with Breton children
Watercolour over pencil on faded white paper, *E.B.* inscribed in
 blue lower R. corner. The sheet is laid down
180 × 139 mm
Provenance: Desiré Louveau, Honfleur (Lugt Suppl. 1694a)
 Marcel Bernheim, Paris, whence sold 1940; J. Reiseger
 Collection; Sotheby's Sale 25th November 1959,
 Lot 100, £60
Colour plate p. 37

This attractive scene, practically a study of light and shadow
rather than a precise portrayal of individuals, is not connected
with any known finished painting but is an independent sketch
in its own right.

Boudin visited Brittany almost every year from 1851–97. By
comparison with his native Normandy, he found Breton patterns
of peasant life and rural cultivation to be unspoilt, and he was
struck by the hold of ancient traditions and customs on the
inhabitants. In his correspondence with his brother Louis[1],
Boudin spoke of his impressions of Brittany at first incredulously
– it fulfilled his dreams – and later, after he had married a Breton,
Marie-Anne Guédès in 1863, with familiarity and continued
fascination. Boudin's early visits were mainly to Quimper, while
from the 1860s onwards he worked almost invariably in Finistère
with occasional trips elsewhere. The majority of his Breton
watercolour sketches were made between 1864 and 1873.

While Boudin's lifelong interests lay in the study of
landscape, sea and sky, he was attracted in Brittany in particular
to the people themselves, their outdoor life and splendid
costumes – the women dressed like queens, as he wrote to Louis.
His sketches capture peasants at work, farm and market scenes,
pardons (traditional religious festivals) and groups of women
and children as here. Boudin endows these rapidly-drawn sturdy
figures in their heavy costumes an air of dignity reminiscent of
Rembrandt. He is intrigued by the contrast of shadowed interior
and dark clothes with the brighter red, blue and white details of
dress, recalling the description in his letters of his visit to Marie-
Anne's parents in Finistère in 1867[2], where indoors his eyes had
to get used to the darkness with figures gradually taking shape in
clearer accents from their bistre coloured surroundings. This
drawing may well date from the period 1867–70 together with a
number of Breton interiors in watercolour, a group of which are
in the Louvre. A rather similar study, an interior with a woman
and baby with two children to the left and a small child on the
right, was sold at the Hôtel Druout, Paris, 4th June 1969, lot 552.

This watercolour originally belonged to Desiré Louveau
(1843–1916) a merchant from Honfleur and an old friend of
Boudin. He owned numerous paintings, watercolours and
drawings by the artist, including several scenes of peasant life,
some of which were sold in 1918. He and his wife also assembled
an important Norman ethnographic collection. The watercolour
later belonged to J. Reiseger, an old friend of Fritz Gross.

[1] See G. Jean-Aubry 'Eugène Boudin. Notes d'un voyage en Bretagne' *Mercure
de France* 15th July 1924, pp. 325-353.
[2] *Ibid.* pp. 330-332.

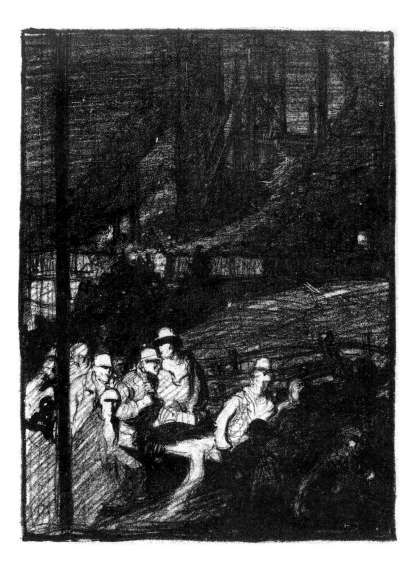

5 Frank Brangwyn (1867–1956)
 The coal mine
Lithograph in black ink on light brown paper. The monogram
 F.B. can be seen in the lower right corner
302 × 222 mm (plate), 328 × 245 mm (sheet size)
Provenance: Unknown

This lithograph was published by the Studio Library in
Representative Art of Our Time, edited by C. Holme, of 1903 (see
No. 55 which was also published there). Brangwyn, a much
travelled artist and designer, was by then well known and
successful in France (he had been made a Chevalier of the Legion
of Honour in 1902) and in the USA (whence commissions
continued to flow for most of his career) although critical opinion
was not always in his favour in Britain – Wyndham Lewis placed
him with Galsworthy, Sidney Webb and the Bishop of London as
a reactionary in *Blast* in 1914. While his allegorical and decorative
schemes may not have pleased Modernists, Brangwyn's prints
were always popular and his war work of poster designs and
lithographs of soldiers in action was effective propaganda, given
his talent for dramatic grouping.

Brangwyn is better known for his etchings – he made over
300 between 1903 and 1926, and published collections of them
were available during that time – than for his lithographs which
have not yet been catalogued and which may number as many as
100. The theme of the worker was a favourite one (and
Brangwyn saw himself very much as a man of the people) in the
early 1900s, leading up to his four large pictures for the Venice
Biennale of 1905 showing blacksmiths, potters, steelworkers
and navvies at work, which won him a gold medal. This
lithograph does not celebrate heroic labour, however, but rather
conjures up a gloomy, hellishly lit mine where anonymous
workers, their features blurred as though spotlit, emerge from
darkness carrying an injured miner in a cheerless procession
which disappears again in thick shadow. Brangwyn obtains
marvellous tonal effects with the richest, darkest parts standing
out like impasto on the surface of the print, while (perhaps
thinking like an etcher) he has used a scratching technique of
thin horizontal lines and curved shorthand strokes to obtain the
subtle light effects in the background. The same subject was
etched by him in reverse in 1905 (see *The Etchings of Frank
Brangwyn* London 1912, No. 59).

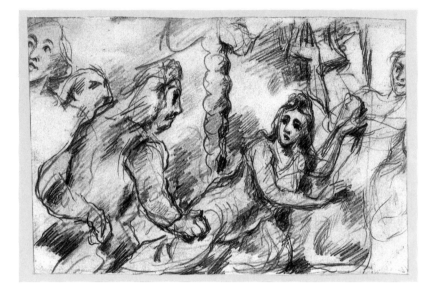

6 **Paul Cézanne** (1839–1906)
 A woman caught unawares
 Verso: A study of tree tops
Pencil on white paper
119 × 173 mm
Provenance: Ambroise Vollard, Paris; Private Collection, Paris;
 Sale, Hôtel Druout (Maître Oury) Paris, 16th March 1959,
 No. 75, repr.
Exhibitions: London, Hayward Gallery and Newcastle-upon-Tyne,
 Laing Art Gallery, 1973 *Watercolour and Pencil Drawings
 by Cézanne* Cat. 8
Literature: A. Chappuis *The Drawings of Paul Cézanne* 2 vols,
 London 1973, No. 125A

This drawing has been cut from a larger sheet of studies once
owned by Ambroise Vollard, who had the whole sheet
photographed. On the sheet were numerous studies of hands
and of female heads to the left and right towards the edge; in
the left part of the sheet was a study of a skull, for which the
sheet had been held vertically, and in the centre were two studies
for the same scene, one above the other, of which this is the top
study. Both of them overlap the head and hand studies. On the
verso was a rough sketch of a landscape with trees.

The scene shows two men threateningly approaching a
woman who is apparently lying on a bed, and she turns away
from them. In the other sketch, the woman is shown in profile to
the left, and the principal man moves towards her more
aggressively. It may be that the Gross sketch was the first idea –
the artist might have worked from the top of the page, and the
man's figure is not as complete as in the other drawing –
although one could also argue that the one below it came first.
Chappuis suggested in a letter to Gross in 1964 that these may
be studies for a lost painting, perhaps one destroyed by Cézanne
or by his sister Marie. In any case, a date of 1865–69 as Chappuis
suggested seems likely (the author in fact proposed that the
fragment with the skull is datable to 1868).

A lost watercolour of 1867–70 known from another of
Vollard's photographs is of a similar scene, although it is called *Le
peintre et la femme:* rather than depicting an artist and his
model it shows a nude woman lying on a bed with a sharp-
featured eager man approaching her with his left arm outflung.
(J. Rewald *Paul Cézanne, The Watercolours* London 1983, No.
33.) Rewald suggested that this figure is Achille Emperaire,
Cézanne's friend whose portrait he painted in 1867–8; his
features are not unlike those of the man in the companion
drawing to No. 6. The subject is one which interested Cézanne
towards 1870; there is a pencil drawing in a sketchbook of
Cézanne's showing a frightened woman on a bed turning away
from the onslaught of four male figures which is datable to
c. 1870–73 (Chappuis No. 289).

While this drawing cannot be connected with any known
painting, it reflects Cézanne's pictorial vocabulary at the end of
the 1860s, which was often of violent or ominous subjects. Many
of these derive from literary sources (and Cézanne's references
were wide-ranging), yet they are far more than the provocative
re-examination of academic tradition – they are serious works
fuelled by his private imagination.

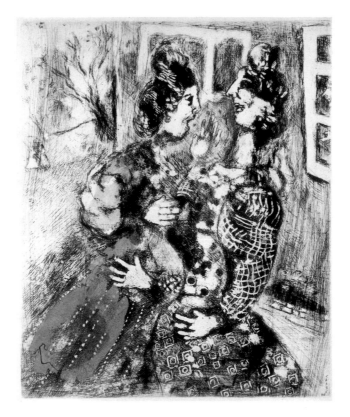

7 Marc Chagall (1887–1985)
 How the women kept a secret
Hand-coloured etching and drypoint on white paper. Signed on
 the plate in lower right-hand corner
291 × 238 mm (platemark)
Provenance: Purchased from Gimpel Fíls, London, 1955, £11.10s
Literature: F. Meyer *Marc Chagall: l'oeuvre gravé* trans.
 P. Chavasse, New York, 1957, No. 77. See also Boston 1961
 No. 52, and Johnson No. 174
Colour plate p. 27

This is an illustration to the edition of 100 fables of La Fontaine
commissioned by Ambroise Vollard in 1927, and finally published
by Teriade in Paris in 1952. Chagall worked on the plates from
1927–30. His two other major projects for Vollard – illustrations
for Gogol's *Ames Mortes* which he worked on from 1923–27,
and for the *Bible* which occupied him from 1931–39 – remained
unpublished for many years. Vollard did not always have the
finance to match up to his passion for fine editions (see also Nos.

3 and 45). Production of *Les Fables* was also held up by a minor
public outcry in the nationalist press at the fact that a foreigner
(and a Jew) had been chosen to illustrate a classic French text.

Originally, *Les Fables* were to be illustrated with colour
engravings, and Chagall provided preliminary gouache designs,
but technical difficulties dictated that etchings be used instead.
Here the fable is of two old women who swear each other to
secrecy but nevertheless manage to spread an item of gossip far
and wide. Chagall worked the copper plate as he might have
worked at an oil painting, building up tonal values in layers. The
background is filled with criss-crossed scratched lines, worked
over in a denser patterning of lines progressively deeper and
darker, while the blackest areas are rich and velvety. Chagall
evokes an atmosphere crackling with excitement as the two
crones revel in their secret. The dabs and spatters of thin colour
on the plate add to this effect. The artist became interested in
colour etching and lithography in the late 1940s, which may
have prompted him to add colour in the belated printing of these
plates.

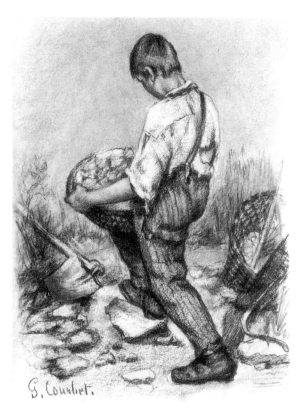

8 Gustave Courbet (1819–1877)
A young stonebreaker
Conté crayon and white chalk on cream paper. Laid down.
Signed *G. Courbet* lower left
294 × 211 mm
Provenance: Aglami family; General Aglami, Roquebrune, Cap
Martin; Serge Rogoff, Menton, from whom purchased in
1966
Colour plate p.20

This beautiful drawing is connected with the *Stonebreakers*, painted in 1849 and exhibited at the Salon of 1850–51 (together with *Burial at Ornans* and eight other pictures) which was destroyed in Dresden in 1945. Courbet described in November 1849 how he had seen two stonecutters at work and how they struck him as a vision of pure misery and poverty; he then invited them, a middle-aged man and a boy, to pose for him in his studio[1]. The painting, one of Courbet's large-scale scenes of everyday life around his native Ornans, was highly controversial, challenging as it did in its realist subject and stiff, frieze-like composition canons of artistic style and decorum.

The boy is shown in reverse with respect to the painting, but otherwise the details seem identical except that his shadow is cast at a slightly lower angle and the gap between his body and the elements on the right has narrowed. There is another drawing of the same figure in the Musée Courbet at Ornans which at first glance appears to be identical to this one[2]. However, the boy's head and ear are more elongated and sturdy in the Gross drawing, the details of costume (the tattered shirt, the pattern of the trousers, the shape of the shoes) are different, as are the surrounding objects such as the stones on the left and

the basket on the right, all of which are closer to the painting in the Gross drawing, while in the Ornans drawing the boy's shadow has been misinterpreted or altered to become a broomstick, while similarly the blade of the shovel, rather than being in shadow, has become partially hidden by the undergrowth.

The latter drawing has been assumed to be a study of 1865 for the lithograph of that figure, printed by F. Gillot, which was published on 17th June 1865 in *L'Autographe au Salon et dans les Ateliers*[3], and which was reproduced again in *L'Autographe au Salon* in 1872. However, in some respects the lithograph follows the Gross drawing more closely, such as in details of the boy's costume, the stone he steps on, those beside him and the foliage in the background. Interestingly, in the lithograph the blade of the shovel begins to be lost in shadow while the boy's own shadow has become more difficult to decipher and could easily be read as a broomstick.

Hence, the Gross drawing may have been the original study provided by Courbet for reproduction in 1865. The Ornans drawing may be a copy after the lithograph either by Courbet himself or one of his students, made perhaps on commission for a client who had seen it in *L'Autographe*[4]. Courbet is known to have made autograph copies on demand, although after 1870 his assistants tended to produce them. Conté crayon and white chalk was a favourite medium of his, especially for highly finished drawings, which he sometimes exhibited. The use of red chalk heightening the black chalk in the Ornans drawing is unusual in Courbet's drawings.

It would not have been difficult for Courbet to provide this drawing for Gillot to print. It could have been made from the painting itself as *The stonebreakers* was not sold until 1867. Or, it

may have been done from a study of the boy in reverse which had been part of the preparatory process in the studio. For instance, there is a study in oil for the painting in the Oscar Reinhart Collection, Winterthur, which shows the entire composition in reverse with respect to the final painting[5]. A further compositional study in oil in a private collection, similarly in reverse, shows the figure of the older man alone[6].

[1] Courbet to M. et Mme. F. Wey, 26th November 1849, quoted on pp. 14-15 of the exhibition catalogue *Gustave Courbet* Grand Palais, Paris 1977–78.
[2] The drawing is in black chalk touched with red on cream paper, and measures 315 × 239 mm. R. Fernier *La vie et l'oeuvre de Gustave Courbet* 2 vols, Wildenstein, 1977, II, No. 52, with further references.
[3] J. Adhémar *La Lithographie française au XIXe siècle* Paris 1944, No.37.
[4] I am grateful to Dr. Petra ten-Doesschate Chu for her suggestions as to the function of this drawing and its relationship with the Ornans drawing, which are here incorporated.
[5] Fernier, I, No. 102, canvas 56 × 65 cm.
[6] P. Courthion *L'Opera completa di Courbet* Milan 1985, No. 97, canvas 45 × 55 cm, signed and dated 1849.

9 Henri-Edmond Cross (1856–1910)
Les Champs-Elysées
Coloured lithograph (red, yellow, pale blue, a darker blue, green) on Chine volant paper (a thin greyish handmade paper)
203 × 263 mm (plate), 254 × 335 mm (sheet size)
Provenance: Purchased from Zeligmann, Paris 1966, £40
Literature: I. Compin *Henri-Edmond Cross* Paris, 1964, cat. 338 and p. 48
Colour plate p. 40

Henri-Edmond Cross's name has been overshadowed by those of Georges Seurat and Paul Signac: he was a faithful member of the Neo-Impressionist group, exhibiting regularly with them. He had taken up the pointillist style around 1890, and used the technique in a stylized and decorative way. Cross made only two colour lithographs: *Nocturne* for Ambroise Vollard's album of artists' prints issued in 1897, *L'Album d'estampes originales de la Galerie Vollard*, which included works by Bonnard, Munch, Renoir, Vallotton, Toulouse-Lautrec, Cézanne, Rodin and Sisley, and *Les Champs-Elysées* for the magazine *Pan* of 31st July 1898.

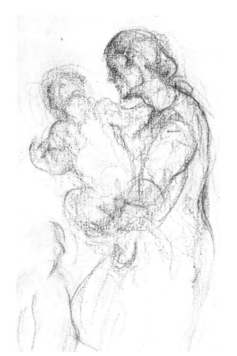

Pan was an avant-garde publication devoted to modern art and literature, and that issue featured a number of colour lithographs by Neo-Impressionists, including one by Signac (see No. 51 below).

The composition is of the busy avenue seen from beneath the trees; simplified, schematic outlines are used. Some of the figures recall the stiffly solemn, almost abstract forms of Seurat's *La Grande Jatte* (1886, the Art Institute of Chicago), for instance the pyramidal bulk topped by a round hat of the figure on the left, although here the geometry is mitigated by the more painterly treatment of shadow. The pointillist touches of colour are applied schematically and decoratively – the observed effects of colour and light are distilled into pleasing patterns with greens and blues framing a central yellow area enlivened by touches of red. Cross also experiments with a looser, more fluent touch as in the head and arm of the seated girl with its slightly blurred effect, or in the bodies of the horses, where an impression of movement is conveyed. A preparatory drawing in coloured crayons for this lithograph is in the Hugo Perls collection, New York.

The critic André Mellerio wrote a survey of colour lithography in 1898, examining the achievements of the decade in what he felt was an important distinguishing feature of the avant-garde – the original colour lithograph. He described Cross as the most rigorously Pointillist whose characteristic round dot hit the viewer in the eye aptly summarizing one of Neo-Impressionism's aims of bombarding the eye with colour sensations.

10 Honoré Daumier (1808–79)
Mother and child
Pencil on faded white paper
101 × 55 mm
Provenance: Otto Gerstenberg (?); Hoboken; Private
 Collection; Sotheby's Sale 3rd December 1958, Lot 111;
 Piccadilly Gallery May 1961
Literature: Maison II, No 218

Daumier was trained as a draughtsman, and drawing was second nature to him. His output of prints and drawings was enormous: although his prints can usually be dated – they were generally made for publication in newspapers – his drawings are far more difficult to place. Daumier seems to have built up a repertoire of expressive heads and of Parisian types which fed his preoccupation with recurring themes – the tough working life of the urban poor, notably washerwomen against a tenement backdrop; the bombast and cynicism of lawyers and judges by whom those of small means and little education could expect only to be swindled; the pretensions of the bourgeoisie towards artistic judgement; railway travel with its total separation of society into classes with concomitant diminution of comfort. He drew with a variety of means in styles ranging from rapid, almost obsessively scribbled strokes of the pen to rough thumbnail sketches and carefully finished watercolours.

The *Mother and child* is one of a number of studies of

women with babies or small children tugging at their skirts, groups which crop up in prints, watercolours and paintings of the subject of laundresses or of fugitives, or in domestic scenes; Daumier's last known painting is of a full-length figure of a woman carrying her child of c.1873. (Maison I 241). This drawing shows a rather gaunt woman, her hair pulled back, straining to hold a child who struggles in her arms; another child is indicated standing at her knee. The mood of the drawing – the mother seems tense and angry and the child is out of sorts – resembles some of the studies of domestic scenes, without being acerbic as in the *Scène de ménage (La correction paternelle)* (M. II 693). However, the woman is of a similar type to the resigned careworn figure nursing her child in the more finished crayon and wash drawing *Une mendiante* (M. II 242) and the two drawings could well be connected.

Curiously, the drawing reproduced by Maison as the Gross drawing is not identical with this one, and the differences do not seem to be due to faults of photography (e.g. the indication of the child lower left is missing, and the woman's hair is different as are the shadows on her back).

11 Honoré Daumier
Head of a man

Pen, ink and grey wash over indications in pencil on faded white paper

The drawing consists of two pieces of paper taped together at the back: the top piece is 36 × 57 mm and the bottom 36 × 43 mm

Provenance: As for No. 10

Literature: Maison II No. 18a

This thumbnail sketch was originally on the same sheet as No. 10. With his staring eyes, hooked nose, sunken cheeks and somewhat desperate expression, this man could have been drawn with a courtroom scene in mind – the theatrical rhetoric of advocates and its effect on their opponents or on the defendants is a common motif with Daumier (e.g. Maison II 655). On the other hand, the man's grimace and the clown-like treatment of his eyes and heavy eyebrows brings him close to Daumier's studies of saltimbanques – miserable performers with poverty staring them in the face (e.g. M.II 534, 553, 556).

12 **Honoré Daumier**
Head study

Recto: Head and shoulders of a middle-aged man in three-
quarters profile looking up to left

Verso: Profile study of the head and shoulders of a bearded
man looking to the left (upside down with respect to the
recto)

Pen, ink and grey washes on white laid paper

105 × 118 mm (inside of aperture)

Provenance: Vente M.B. Paris, Hôtel Druout 1936; P.M. Turner,
London; purchased from Reid and Lefevre, 9th January
1956, £180

Exhibitions: Oxford, Maison Française 1950 *Quelques artistes
français de la collection P.M. Turner* No. 8

Ingelheim, 1971 *Honoré Daumier* No. 20 and No. 21 (*verso*)

Literature: Maison II No. 14 and No. 60 (*verso*)

See the comments at No. 10 above. The expressive head on the
recto, modelled strongly in light and shade, shows Daumier at his
most sensitive. A layer of light wash has apparently first been
used with some light indications of the pen, then a darker wash
added with definitive pen strokes on top. The tentative, nervous
lines and the marvellous use of the whiteness of the paper
suggest every fleshy fold and wrinkle of this large middle-aged
man's head and neck. As a type, this man is close to the figure on
the right in Daumier's highly finished drawing *Les Bons Amis*
(Maison II 319). It may be that this head, with its expression of
fear and disbelief as though caught in a spotlight, was conceived
as part of a study of a theatre audience engrossed in some
popular melodrama (e.g. M. II 496, 505).

The near-caricature profile study on the *verso* of a
vigorously-drawn, villainous character could connect with any of
a number of themes from crowd scenes to legal drama. There is
even some resemblance to a profile head of an advocate (M. II 670).
This drawing is far more tightly and scratchily worked than that
on the *recto,* again using a light wash beneath a slightly darker
one; however the shadowing here is built up through a network
of hatching, cross-hatching and overlapping pen lines, fiercely
drawn.

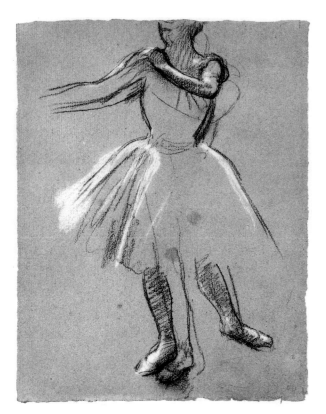

13 Edgar Degas (1834–1917)
 Ballet dancer
Charcoal and white chalk on thick buff paper with some stains.
 Laid down
310 × 233 mm (slightly irregular)
Provenance: Purchased from Rowland, London, 1954, £140
Colour plate p. 21

Degas made an enormous number of paintings, pastels, drawings, monotypes and wax or clay models on the theme of the ballet – dancers, rehearsals, performances, backstage scenes – from the early 1870s to the end of his life. It was fashionable to attend the Opéra, and season ticket holders mingled with the dancers backstage; thus the subject was one which appealed to painters of modern city life like Degas, Manet, or Renoir. Some of Degas's friends like the composer and dramatist Ludovic Halévy or the musician Desiré Dihau formed part of the management of the Opéra and through them he had access to the rehearsal rooms. But the artist's continual exploration of the theme goes far beyond that of a strong interest fostered by such circumstances: it seized his imagination for good. Part of this obsession was with the sheer amount of painful exercise and perfection of technique which made the dance possible (akin to the relationship of an artist and his art); indeed far more of his works on the ballet theme are concerned with learning, practice or the build-up to dancing than with the performance itself. Degas was intrigued by the raw material of the ballet – the working-class girls, often awkward or clumsy, stretching and bending, who on rare occasions could be transformed in a perfect fusion of music and movement.

This drawing probably dates from c.1880–3, and is a life-study, probably from a model in his studio. Degas rarely drew at length backstage, but preferred to work in his own atelier, sometimes with dancers from the Opéra posing for him and more often with professional models in ballet dress. He made a large quantity of drawings of individual dancers, many annotated, from the late 1870s to the mid 1880s. This drawing, like most, is not a preparatory study for a particular work, rather it is part of a continuous investigation and exploration of a familiar theme. Such drawings came to provide a repertoire of poses and images which Degas could turn to later, to re-use or alter, with specific purposes in mind. His figures are so closely studied that very often parts of them are cropped by the edge of the page, as here (parallel to the way in which figures are broken off by the frames of his pictures). They are rapidly executed, with revisions as the artist made more than one attempt to capture exactly the position of the limbs. These individual studies were usually made with charcoal or black chalk, heightened with white, on tinted paper, often on a sheet of this size. Two drawings are rather similar to this one (*Vente Degas* III, 112.2 and IV, 275b) in style and in the model's pose, although they need not have been made at the same time.

Degas concentrated here on the positioning of shoulders, arms and legs; having begun by treating them as separate elements, he unified the figure (which is anatomically disjointed) by indicating the fall of light from instep to shoulder. The dancer's gesture of adjusting her shoulder-strap was a favourite one with Degas (here it adds vigour to the form and breaks up a frontal view) which he constantly used from the early 1870s, and its source can be found in his early academic life-studies and drawings from the antique. (See R. Thomson *The Private Degas* Arts Council of Great Britain 1987, p. 115. I am grateful to Richard Thomson for his suggestions as to the dating and function of this drawing.)

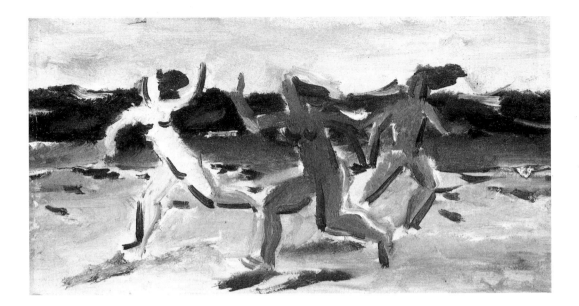

14 André Derain (1880–1954)
 Bathers
Gouache on paper
172 × 320 mm
Provenance: Mme. André Derain; purchased Musée de l'Athenée,
 Geneva, September 1959, £566
Colour plate p. 36

This small painting of exuberant nude figures is executed with gusto in a highly restricted scheme of cobalt blue and coffee colours. The theme of nudes by the sea in an Arcadian atmosphere, or with overtones of primitive innocence and freedom from inhibition, was popular with Derain and his friends in the Fauve group like Matisse or Vlaminck from around 1905. Derain's palette however in his Fauve years was of scintillating bright colours and his technique was one of broken touches and dabs of paint which eventually became more solid and fluent. By about 1907–8, Derain had moved away from pure, high-pitched colours and tended to paint in a narrower range of half-tones, greys, browns, greens and blues, a move in which he was followed by Braque. Derain was close to Picasso and Braque, and

although he did not commit himself to Cubism, he had been among the first to take serious note of African art and its value for avant-garde painting and sculpture. He gradually abandoned the avant-garde by 1911 or so, following instead, in his continuing search for a personal style, an interest in Italian and French primitives. Apollinaire was to write of Derain in the preface to the catalogue of his first one-man show of 1916 that he had an expressive grandeur which was quasi-antique but not deliberately archaic, and that while he had direct experience of all that contemporary art achieved the result was simplicity and freshness.

It is possible that this picture dates from a transitional period in Derain's work, around 1910, especially given the colour-range and the prominence of the theme of bathers, or bathers and dancers combined, in his work up to then. However, the painting is enigmatic in that late in life Derain returned to this theme with renewed interest and equal freedom of execution, producing a number of small paintings of *Bathers, Nymphs,* or *Bacchantes* around 1945–50. His nudes there are more calligraphic and schematic, however, and there is less effervescence than in this picture which, on balance, is more likely to be an early work.

15 André Derain
Pantagruel
Coloured woodcut on cream paper
69 × 70 mm
Provenance: Purchased at the Erskine Gallery, London 1955,
£2.2s
Literature: F. Chapon *Le peintre et le livre: l'age d'or du livre
illustré en France 1870–1970* Paris, 1987, pp. 155-6 and
pp. 288-9, Boston 1961 No. 81
Colour plate p. 26

This is one of the illustrations commissioned from Derain by the
publisher Albert Skira in 1940 for his edition of Francois
Rabelais's *Pantagruel* (*Les Horribles et Espouvantables Faictz et
Prouesses du très renommé Pantagruel roy des Dipsodes fil du
grand géant Gargantua composé nouvellment par Maître
Alcofrybas Nasier*) of 1943. Derain provided 179 woodcuts,
including full-page illustrations with the deeds of the main
protagonists, elaborate designs for capital letters, and little
vignettes with animals, landscapes, caricatures or minor figures.

275 copies of the book were printed, some with extra sets of the
woodcuts. This woodcut appeared on p. 165, the first page of
Book 2, Chapter XXX, where Pantagruel cries at the death of
Epistemon, but Panurge skilfully sews the latter's head back on.

Derain's inspiration was from medieval books, playing-cards
and manuscripts, with their brightly-hued stencil-printed or
hand-painted illustrations and their often comical and grotesque
imagery. The technique he chose was a one a medieval
craftsman might have used. His preliminary line drawings were
transferred to the woodblocks, but instead of the usual practice
of cutting separate blocks for the individual colours, a white line
was cut on each block to separate the colour areas. The blocks
were then inked by hand in several colours through stencils
under Derain's supervision and printed on dampened paper.
There is no superimposed colour, no mixing of colour in the
printing, while the white line isolates different masses giving the
effect of flat, cut-out forms. A special studio had to be set up for
the printing of *Pantagruel* in the Atelier Lacourière with a team of
printers, and the whole process took two years.

16 **Jean-Louis Forain** (1852–1931)
 Maison close (Brothel)
Etching in black ink on cream handmade paper
94 × 145 mm (image), 99 × 150 mm (platemark),
235 × 318 mm (sheet size)
Provenance: Purchased from Craddock and Barnard, London,
 1965
Literature: M. Guérin *J.L. Forain Acquafortiste* Paris, 1912,
 No. 21; A.C. Faxon *Jean-Louis Forain. A Catalogue
 Raisonné of the Prints* Garland, New York and London,
 1982, No. 22

This was designed as an illustration for *Croquis Parisiens* by
J.K. Huysmans, published in 1880, but Huysmans refused it as
inappropriate to the subject of the relevant section, *Folies
Bergères.* Forain had known Huysman since 1876; he made a
pastel portrait of him in 1878, and his earliest book illustration
had been in 1879 for the second edition of *Marthe,* the tale of a
prostitute, while Huysmans went on to praise Forain in *L'Art
Moderne* of 1883. *Croquis Parisiens* had an etched frontispiece
and three etchings by Forain, and four etchings by Raffaelli.
Some of the published copies had refused designs bound into

them, while the plates were purchased by M.G. Pellet some time
before 1912 and a small edition pulled from them.

Forain's chosen subjects have much in common with those
of Degas, whose work he admired tremendously, and whose
interest in unusual angles of vision he shared. Here the viewpoint
is ambivalent; we look down at the flat rectangles of tables set
obliquely, but the reflections in the mirrors suggest a low
viewpoint. The composition echoes that of Degas's *Absinthe* of
1876. The subject anticipates some of the more humorous
'cabinet particulière' scenes (see No. 17), where a diminutive
man (a client or a friend) is all but ignored by the gossipping girls.

The plate is subtly worked, with thin scratching giving
practically indiscernible shadowing on the faces, while the sheen
of the mirrors is conveyed by a more dense scribbled network;
Forain allows the blank paper to suggest a variety of textures. The
etching is very freshly and spontaneously worked in a manner
that was relatively new in the late 1870s for an artist who went
on to a successful career as a satirical and witty illustrator.
Manet's etchings are comparable in their freedom, but on the
whole they were not made for publication and did not appear in
his lifetime.

17 Jean-Louis Forain
 Scène de cabinet particulière (Scene in a private room)
Transfer lithograph in black ink on white paper, *f* in lower right
 corner on plate, *78/46* in pencil on *verso*
232 × 285 mm (image), 295 × 336mm (sheet, irregularly cut
 along lower edge)
Provenance: Purchased from O.W. Gauss, Munich, 1966
Literature: A.C. Faxon *Jean-Louis Forain. A Catalogue Raisonné
 of the Prints* Garland, New York and London, 1982,
 No. 260

From around 1893–1910 Forain explored the subject of the
'cabinet particulière', first as neutral reportage, and later,
especially after his religious conversion in 1900, from a moral
point of view. In some Parisian cafés, upstairs rooms were
available for private and often illicit rendevous, while clients
could also take the serving girls there. The life of the prostitute
had been a subject in literature and art from Dumas's *La Dame
aux camelias* of 1848 to Toulouse-Lautrec's brothel scenes (see
No. 59), but Forain is possibly unique in recording the seedy
exchanges in these private rooms.

Forain's sharp eye and wit are evident here in the depiction
of an obese client, whose fleshy chins are indicated by a
smudged shadow and whose features are summarily drawn

except for the large nose and heavy moustache which emphasise
his gloating anticipatory grin. His hand at the woman's waist and
his thick fingers perhaps holding an invisible glass but ready to
encircle the woman are also strongly drawn. The woman stands
away from him, letting her hair down in what should be a
seductive gesture, but she is thin, a little hunched and her dress is
plain, suggesting that she is new to the game, a victim rather
than a manipulator. Another version of this image in a vertical
format is more direct in its message, with a more dashing,
bewhiskered client already pouncing on the woman as she
adjusts her hair. (Faxon No. 259)

A preliminary black crayon drawing on tan tracing paper is
now in the Art Institute of Chicago (Joachim II 387). When Forain
began lithographic work in 1892, he preferred to do his own
printing and he generally drew with the lithographic crayon
directly onto the stone. As the demand grew for his designs, and
in order to save time, he turned to drawing on transfer paper (a
specially prepared paper whose surface layer dissolves and
allows the drawing to adhere to the stone) and handing the
paper to professional printers. With transfer lithographs some
loss of definition inevitably occurs (although the drawing can
always be re-worked on the stone) and the grain of the paper is
usually visible. This lithograph dates from c. 1905.

18 Paul Gauguin (1848–1903)
 Self portrait
Pencil, the main contours worked over with a waxy crayon, on
 cream (slightly faded) paper with splashes of paint. Laid
 down
138 × 115 mm
Provenance: Marie-Henry, Le Pouldu; Private collection; Paris,
 Hôtel Druout, Sale 16th March 1959, No. 114
Exhibitions: Marlborough Fine Art Gallery, London, Summer
 Exhibition 1959, No. 23; Paris, 1960, No. 64; Munich,
 1960, No. 89

Gauguin and the Danish painter Meyer de Haan (who was friend,
pupil and when necessary a source of funds) stayed at the inn of
Marie-Henry at Le Pouldu, some 15 miles down the Breton coast
from Pont-Aven, from 2nd October 1889 until early February
1890. Too many artists were discovering Pont-Aven. They were
joined by their like-minded friends Paul Sérusier and Maxime
Maufra, and together they decorated some rooms of the inn
with paintings on panel and on cardboard, small sculptures, and
lithographs on yellow paper. Among Gauguin's contributions
were some self-portraits: *Bonjour M. Gauguin,* a gloomy re-
enactment of Courbet's confident picture, on the door of the inn
and *Self-portrait with a halo and a snake* on a cupboard door
(Wildenstein 321 and 323). Many of the works he painted
remained in the possession of Marie-Henry (as security for

outstanding debts) and this drawing originally belonged to her.
Around the same time – probably November 1889 – Gauguin
painted his *Self-portrait with The yellow Christ* (W.324) (which
included in the background a self-portrait in stoneware made
earlier that year). This drawing has some elements in common
with that painted portrait – the shape of the head and hair, and
the schematic treatment of the planes of the face. Another
sightly larger and more elaborately worked version of this
drawing exists[1].

Gauguin was obsessed with depicting himself in these
months (although the self-portrait was a favourite theme of his)
partly because he was acutely depressed due to poverty and a
sense of failure and betrayal. He had fled penury in Paris for
Panama and Martinique in 1887, returning after illness with
some plans, which came to nothing, for financing himself
through his ceramic work. Not only that; he had been stung by
adverse criticism of his recent work from Theo Van Gogh and
Degas. That the features of Christ in *The agony in the garden* of
summer 1889 and in *The yellow Christ* (probably begun in Pont-
Aven and finished in Le Pouldu) resemble Gauguin's own is not
surprising (W. 326 and 327). On the whole, Gauguin made self-
portraits as gifts for friends and relatives – they were not
intended for sale or even for public exhibition.

[1] In a private collection, reproduced in R. Huyghe *Gauguin* Bonfini Press, 1988,
p.7, 185 × 295mm.

19　Paul Gauguin
　　Study for 'Tahitian women on the beach'
Pencil and red chalk on cream paper. The sheet is made up with
　　a strip across the top including part of the studio stamp,
　　visible on the *verso*. The studio stamp, faint, is also on the
　　lower right corner of the *recto*, and is more clearly stamped
　　on the *verso* in the same position
Recto: Study of a nude man seen from behind. There are some
　　paint splashes and rubbings of crayon. The incised outlines
　　of the right foot can be seen some 3 cm above the pencil
　　drawing
Verso: Page of studies, clockwise from L: part of a figure
　　crouching or running uphill (an alternative reading is part
　　of a study of the hindquarters of a dog); detail of costume
　　(?); nose, mouth and chin (in red chalk); nude female
　　figure (eyes and lips picked out in red chalk); head of a
　　cow; study of female Breton costume; detail of a figure
　　carrying a basket; two men in conversation
263 × 161 mm (inside of aperture). Probably 267 × 170 mm,
　　as described in the Gross family notes
Provenance: H.S. Reitlinger collection (Lugt 2274a), sold
　　Sotheby's 14th April 1954, lot 371. Purchased from the
　　O'Hana Gallery, London, November 1954, £35
Exhibitions: Munich, 1960, No. 100
Colour plate p. 29

The sturdy figure on the *recto* is clearly connected with a painting
Tahitian women on the beach made during Gauguin's first visit to
Tahiti (1891–93), probably in 1891 (Wildenstein 456). The
picture shows two native figures, nude: a woman on the left
facing the viewer, and the other figure on the right in exactly the
same pose as in this drawing, whose softer profile and long hair
resemble those of a woman rather than those of a man as here.
Gauguin made a quick pencil sketch and then emphatically re-
worked parts of the contours in red, broadening and simplifying
the figure even further so as to achieve the vigour of a relief
wood-carving and the hieratic quality of an Egyptian-type pose.

　　The group of studies on the *verso* seems to relate to work
executed during Gauguin's stay in Brittany in 1889-early 1890.
He often re-used studies and returned to earlier motifs, and
could well have brought the sheet with him to Tahiti. The motif of
a Breton woman posed hand on hip is one which he explored
from around 1886 (as in a painting of that year (W.201), a pastel
costume study connected with it, now in the Burrell Collection,
or a ceramic vase of 1886–7 now in the Musée d'Art et d'Histoire,
Brussels) while similar costume studies also occur in his small
Breton sketchbooks[1]. The other Breton study just above it is
possibly connected with a fan design of *Breton girls in a
landscape* of c. 1889 where one girl is seen from behind holding
perhaps a basket (W.342).

　　In many ways the sheet is reminiscent of the type of

60

sketches jotted down in the small notebook or *carnet* of either 1888 or, more likely, 1889–90. This contains studies of dogs, cows, foxes, figures, heads, Breton costumes and caricatures, and in a few instances Gauguin shows a taste for simplification and for capturing figures from unusual angles, or foreshortened almost as in puzzles. The top left sketch on this sheet reflects this taste: at first glance it could be interpreted as the study of a peasant in clogs crouched over, or moving uphill – a similar type of simplified figure, bent, with an elongated arm can be seen in the painting *Entrée de ferme* of 1890 (W.393). On the other hand, it could be a study of the hindquarters of a dog, whose front leg is rather like that sketched on p. 191 of the *carnet,* and which recalls a more easily-identifiable sketch of a whippet in a drawing of 1889[2]. The two round-hatted men in conversation are types which appear in a number of Breton landscapes – sometimes in groups, usually at work in the fields – and also in sketches in the *carnet* (e.g. p. 153). Again, the cow's head is a common motif in these landscapes: very similar heads can be seen in *Haymaking in Brittany* of 1889 or the watercolour *Cows in a landscape* which may have been made at Le Pouldu (W.352 and 343bis). The costume study could be associated with details in paintings of simplified seated figures, but this sketch is not so much a simplification of a motif as a quick scribbling of something observed. It is most similar to the rough clothing of the *The cowherd,* a watercolour of 1889 – she wears a high-waisted skirt with a loose blouse with rolled-up sleeve and carries a water-jar (W.343). None of these sketches may be related to finished paintings; what is important is that they display Gauguin's pictorial interests and the vocabulary of his last works in Brittany before he prepared to leave Europe for Tahiti.

In the same way, the remaining sketches reflect other aspects of Gauguin's work which he was to develop in Tahiti. Gauguin explored the female nude in Brittany in compositions of bathers, in the theme of *Ondine* (a woman entering the waves, seen from behind with her arm upraised) which appears in a painting, a fan design and a print; in a wood sculpture *Femme caraibe* and, closer to this drawing, in a pastel of *Eve Bretonne* of 1889 (W.333) – Eve is a seated figure but her features are similar. The separate study of the mouth may well have a connection with the painting *Nirvana: Portrait of Meyer de Haan* of 1889 (W.320) in that the detail of the anguished Eve-type woman (a reference to *Eve Bretonne*) behind his head is strikingly similar to this drawing.

[1] R. Cogniat and J. Rewald *P. Gauguin Carnet de Croquis* Hammer Galleries, New York, 1962, with sketches from 1886–88, and R. Huyghe *Le Carnet de Paul Gauguin* Paris, 1952, from 1888 or 1889–90.
[2] *Breton peasant and dog* charcoal, private collection Paris; repr. Tate Gallery *Gauguin and the Pont-Aven Group* 1966, No. 52.

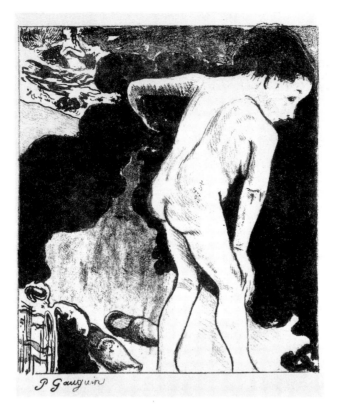

20 Paul Gauguin

Baigneuses Bretonnes (Breton bathers)

Zincograph (lithograph on a zinc plate) in black ink on imitation Japan paper (a smooth, thick cream paper)

234 × 201 mm (border), 245 × 201 mm (plate), 285 × 395 mm (sheet size). The head of the principle figure juts beyond the printed border. Signed *P. Gauguin* on the plate below the border on the left

Provenance: Purchased from Hauswedell, Hamburg, 1961

Literature: Guérin No. 3; Joachim, Kornfeld and Mongan No. 4B

This is from the second edition published by Ambroise Vollard (who had bought the zinc plates from Gauguin's friend Émile Schuffenecker) after 1900. The first edition was published by the artist in 1889, printed on bright yellow paper. *Baigneuses Bretonnes* was the fourth in a set of ten zincographs which Gauguin made (as he wrote to Van Gogh) in order to publicise his work; the designs were all based on earlier work done in Pont-Aven, Arles and Martinique. The set was first on public show as part of an avant-garde exhibition – 'Exposition de Peintures du Groupe Impressioniste et Synthetiste' put on in the Café Volpini in the grounds of the Universal Exhibition in June 1889. Some of the prints were reproduced in the catalogue, although they could be seen only on request.

Gauguin is not known to have made any lithographs before 1888. In this series, the first two prints reproduce earlier designs, and those following gradually become less dependant upon established compositions as Gauguin explored the possibilities of his medium. Zinc plates are cheaper than stone and are portable, which is probably why Gauguin chose them; they are slightly coarser to work with than the lithographic stone, although the perceptible differences are miniscule. What was highly original was Gauguin's bold use of large sheets of canary yellow paper, so that the black lines and grey washes floated on a sea of pure colour. Although he made only 12 prints before going to Tahiti, Gauguin's work had a major impact on the printmaking of the other artists of the Pont-Aven group.

This image of the woman shrinking from the water is one which occurred in a number of works from 1886–7; a painting (Wildenstein 215), a pastel and gouache fan design (W.216), a drawing in charcoal and pastel now in the Art Institute of Chicago (Joachim II, 3E2) and a ceramic vase dated 1888 (M. Bodelsen *Gauguin's Ceramics* London, 1964, No. 41). The unusual angle of vision with the decorative treatment of rocks and sea recalls Gauguin's interest in Japanese prints, while the division of the composition suggests a symbolic meaning as a more relaxed bather at the top left abandons herself to the water.

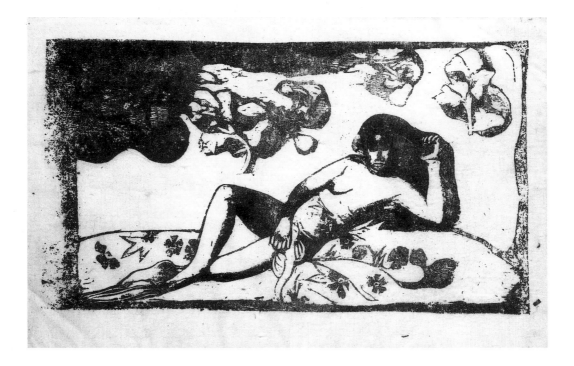

21 Paul Gauguin

La Femme aux mangos — fatigué (Woman with mangoes — tired)

Woodcut in black ink on thin, tissue-like Japan paper

170 × 304 mm (image)

Provenance: Bought in Paris, possibly in 1959

Exhibitions: Paris 1960, No. 140; Munich 1960, No. 199

Literature: Guérin No. 62; Joachim, Kornfeld and Mongan
No. 44A

This is one of about 30 impressions printed by Gauguin in Tahiti in 1898. Gauguin had produced his first woodcuts in 1893–4 when he returned from Tahiti to Paris. At that time there was a strong revival of interest in woodblock printing and wood engraving, partly as a result of a major exhibition of Japanese prints in the spring of 1890 at the École des Beaux Arts — Felix Vallotton was inspired by this — and also because of a new taste for the archaic and the primitive which the roughly-cut woodblock could express — Émile Bernard had taken up wood engraving in 1888, and Maurice Denis in 1892. However, Gauguin's efforts were emphatically original and unique, anticipating in their powerful expression the graphic work of Munch at the end of the decade. A critic Charles Leclerque described them as intermediaries between painting and sculpture — the woodblock like a carving in relief leaving a richly tonal imprint (and Gauguin often used coloured or blended inks, or printed deliberately off register to evoke different responses)[1]. As can be seen in this print, Gauguin

was seeking neither a decorative effect (the image is deliberately unclear) nor the reproduction of 'primitive' art. It is a haunting, sombre image, distilled from an earlier painting but harsher than its prototype. Gauguin enthusiastically described in a letter to his friend Daniel de Monfried of April 1896 the image of a naked, reclining queen in a landscape of fruit-trees and seashore which he was painting (Te Arii Vahine, W.542). Sources for Gauguin's image as diverse as Manet's Olympia (which he had copied), Lucas Cranach's Diana reclining of c. 1537 (a photograph of which he owned), or a figure in relief on a temple frieze in Java which he would have seen in his travels, have all been discussed[2]. For the first time, Gauguin squarely placed a Tahitian female nude in the grand tradition of western painting, yet the work retains its own strong identity, particularly as a result of the deep, sonorous colours, and the unidealized form of the nude.

The artist was fascinated by this queen he had created; he sketched her in watercolour in his letter to Monfried; she recurs in a woodcut for Le Sourire of 1899–1900 (J.K. and M. 72), in a monotype of 1900 l'Esprit veille (Tahitian woman with evil spirit) (R.S. Field Gauguin Monotypes Philadelphia, 1973, No. 66), and as late as 1903 in a drawing of p. 121 on Gauguin's manuscript Avant et Après.

[1] For Leclerque's comments see the catalogue The Art of Paul Gauguin, National Gallery of Art, Washington, and Art Institute of Chicago, 1988, p. 317.
[2] Ibid, No. 215, with a full discussion of the sources.

22 Paul Gauguin
 Design for a title for *Le Sourire*
Woodcut in black ink on a thin tissue-like Japan paper. With the
 title *Le Sourire;* upper left *Taiti;* centre left *3 Raira* (the
 price), and with the monogram *P.G.* and the number *23* in
 the white space bottom left
113 × 185 mm (image), 145 × 220 mm (sheet size, irregular)
Provenance: London, Redfern Gallery 1944; Miss Diana King;
 Mrs. V. Vernon; purchased Sotheby's Sale 10th July 1961,
 Lot 77
Literature: Guérin, No. 76 (without mentioning this edition);
 Joachim, Kornfeld and Mongan No. 69, III A

This title was for a satirical, polemical newspaper written and
printed by Gauguin in Tahiti in 1899–90, of which there were
nine issues and three supplements; it was the only illustrated
journal on the island and 30 examples of each copy were
produced. The text was handwritten on a stencil, and drawings
were added[1]. Woodcuts appeared from the second issue, while
after the fourth one, Gauguin replaced the pen drawings at the
top of the first page with woodcuts; at the same time he ceased
sub-heading *Le Sourire* 'Journal sérieux' and instead called it
'Journal méchant', while the tone became more anarchistic and
judgemental. While the newspaper – with up to six illustrations –

was printed on poor quality paper, Gauguin also pulled some
separate proofs on Japan paper to send to France for sale. The
imagery was of Tahitian figures, masks, birds and animals, often
imbued with Gauguin's own sense of symbolism – the fox for
instance could denote lust or perversity[2].

This design, together with a number of others, was not used
in any of the newspaper issues. Here in its third and final state it is
from an edition of about 30 prints numbered by the artist. The
image is cut from a block which has a title page design for the
November 1889 issue of *Le Sourire* cut on the other half (J.K. and
M. 58), and in fact the Gross print overlaps with the bottom of
the other design (which was run off at the same time) having
been cut a little too low. On the other side of the woodblock is
Mahana Atua of 1894–5 (J.K. and M. 31); Gauguin had brought
the block from Paris to Tahiti in the summer of 1895.

[1] See the facsimile edition *Le Sourire de Paul Gauguin* ed. with Introduction and
 notes by L-J. Bouge, Paris 1952.
[2] Gauguin described the fox as the Indian symbol of perversity in a letter to Émile
 Bernard of 1889; it seems to symbolize lust in the painting *Loss of innocence* of
 1890–91 (Walter J. Chrysler Collection, New York), or the wood-carving *Soyez
 amoreuses* of 1889 (Museum of Fine Arts, Boston). Another wood-relief of
 early 1889 *Eve and the serpent* (Ny Carlsberg Glyptothek) includes a rabbit
 amongst other animals.

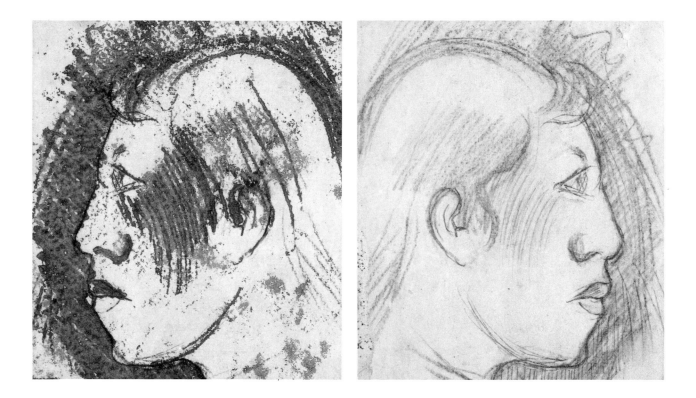

23 Paul Gauguin

Head of a Marquesan girl

Recto: Traced monotype in brown ink on tan wove paper

Verso: Red chalk and pencil, with a little spattering of ink on the left

131 × 115 mm (inside of aperture)

Provenance: Winthrop Newman; Christie's Sale 16th December 1938; Hugo Perls Collection, New York; Sotheby's Sale 5th May 1965, Lot 144, £1200

Exhibitions: New York, Wildenstein & Co., 1946 *Paul Gauguin* No. 54; Houston, Museum of Fine Arts, 1954 *Paul Gauguin: his place in the meeting of East and West* No. 36, catalogue by H. Dorra; Philadelphia, Museum of Art, 1973 *Paul Gauguin Monotypes* No. 91 and pp. 32-33, catalogue by R. Field

Colour plate p. 32

A monotype is a unique image, usually achieved by inking an unworked metal plate and printing it — although a second impression may be obtained, it is inevitably very faint. With the revival of taste for original artists' prints in the late 19th century, there was a renewed interest in experimentation and in the manipulation of ink and paper. Degas and Gauguin were particularly interested in monotype as a means of exploration and development of drawings. Gauguin was always intrigued by the possibilities of transferring images from one medium to another (see No. 20 and 21). In Brittany in 1894 he had experimented with printing wet watercolours onto blank sheets. In Tahiti, he cut woodblocks but had no plates or printing press with which he could have produced etchings or zincographs, hence he took up again around 1899–1900 the possibilities of printing using ink and paper only. He would roll out printer's ink on paper, lay a second sheet on top and draw — the thinner the pencil the finer the line. An inked imprint with the image in reverse on the other side of the sheet would be the result. He could stop at any point and allow the ink to dry, then change to a different ink or a heavier drawing tool; inks were also blended or diluted, while the type of paper varied — Gauguin chose different sorts of paper for their texture, colour and absorbency, while an element of accident or chance was also present throughout the process. In his last years, monotypes practically replaced charcoal and pencil drawings and often acted as studies for paintings.

In this traced monotype, Gauguin first made the red chalk drawing and then to re-inforce the image, and to achieve a different effect in the ink, went over the main contours with pencil. According to Field, at some point oil or solvent was added to the inks so as to obtain thicker lines and alter the colour. It probably dates from late 1902.

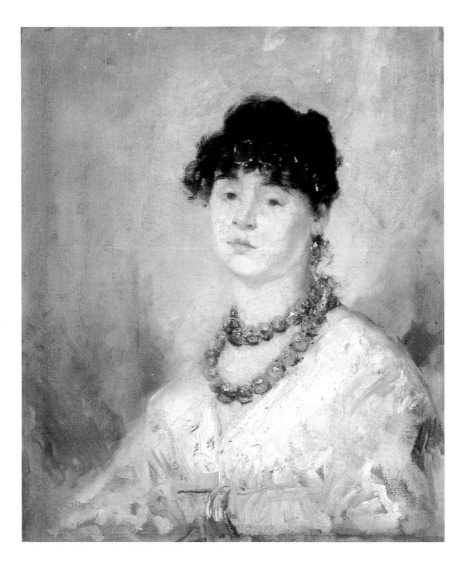

24 Eva Gonzales (1849–1883)
Portrait of Jeanne Gonzales
Oil on canvas. The signature *E.G.* is visible on the lower edge of
the canvas where it has been nailed to the stretcher
460 × 375 mm
Provenance: Mme. Guérard (the sitter); Mme Dudouit, Pau;
purchased from the Galerie Saint-Charles, Monte Carlo,
2700 francs, probably early 1960s
Colour plate p. 30

The daughter of a novelist, Eva Gonzales grew up in the
company of writers and artists. She studied painting under
Charles Chaplin, a fashionable Salon artist, until Alfred Stevens
introduced her to Manet in early 1869. Manet asked her to sit for
him, and also took her on as his only pupil. His portrait (now in
the National Gallery) shows her seated at her easel painting a
flower-piece; it was shown at the Salon of 1870. Gonzales
exhibited a pastel and a painting *Little soldier* in that year, and
although she was listed as a pupil of Chaplin her affiliations with
Manet were noticed by critics like Castagnary, who praised her
work but advised that she leave Manet's studio. She enjoyed a

certain official success, along with some rejections by the Salon
jury. In 1879 Gonzales married the engraver Henri-Charles
Guérard; she died in 1883 a few days after having given birth to
a son, less than a week after the death of Manet.

Gonzales's oeuvre consists of portraits (many of her sister
Jeanne, also a painter), scenes of figures out of doors or at the
theatre, domestic scenes of women at their toilette or resting,
and still-lifes and flower-pieces. Many of her works are in pastel.
Manet had taught her to sketch rapidly what she saw, avoiding a
struggle with precise detail and observing instead the overall
tonal relationships, the brightness and darkness of colours. This
freshly painted portrait, with the loose, sketchy quality of the
dress, and the heavy amber necklace rendered in a rich impasto,
reveals how well Manet's lessons were absorbed. Above all the
exquisitely restricted colour-range of cloudy greenish-greys,
Naples yellow and ochre, which endow the flesh with warmth by
contrast, evokes the tonal harmonies of Goya, an artist whom
Gonzales undoubtedly admired.

Jeanne Gonzales married Guérard after her sister's death;
this portrait comes from her collection.

25 Max Liebermann (1847–1935)
 Beach scene

Transfer lithograph in black ink on thick cream paper, slightly
 faded. Signed *M. Liebermann* in pencil lower left, below
 the plate. An elaborate embossed stamp is visible lower
 left showing an urn on an altar with an animal stretched
 below and the letters B and C on either side (presumably
 the stamp of the publisher Bruno Cassirer)
100 × 162 mm (border), 102 × 165 mm (plate), 255 × 343 mm
 (sheet size)
Provenance: Probably bought from Klipstein, Berne, June 1965
Literature: G. Schliefer *Max Liebermann, sein graphisches Werk*
 Berlin, 1923, No. 142 (153 in 1914 edition)

Liebermann took up printmaking relatively late – the majority of
his etchings date from after 1888, while he began to make

lithographs in 1895. His interest in printing came at a time when
his paintings were changing, in execution and mood, from
painstaking descriptiveness towards spontaneity of effect, as a
result of the impact of Dutch painting and contemporary French
painting which he saw in his travels abroad. The theme of young
bathers and beach scenes was a favourite one with Liebermann,
recurring in etchings, lithographs and paintings. This scene is
akin to an oil painting of children digging and playing on a windy
beach, dated 1908 (now in Hannover). The lithograph was
published in 1912 by Bruno Cassirer. Liebermann made transfer
drawings (on a specially prepared paper which would dissolve
and allow the design to adhere to the stone) for his lithographs
after 1909. This example is a proof with subtle corrections; he
touched up with lithographic chalk the deepest shadows on the
three foreground figures.

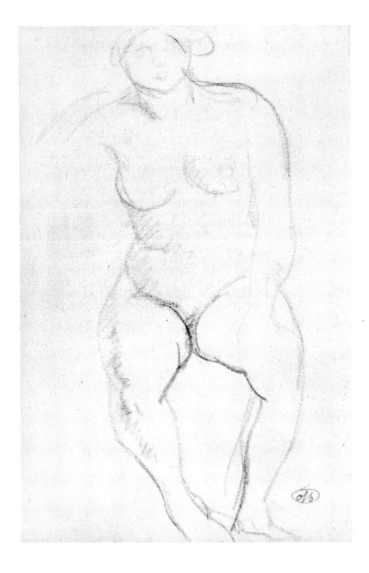

26 Aristide Maillol (1861–1944)
 Seated female nude
Blue pencil on white paper, laid down. Signed with the
 monogram M. The paper appears to be a page torn from a
 printed book, as part of the text in German is just visible,
 upside down, on the reverse
253 × 163 mm
Provenance: Dr. Brill, Vienna; purchased through Jarray, Paris
 1955, £35
Colour plate p. 22

Maillol's early training was as a painter, and he was a friend and
admirer of Gauguin and one of the Nabis group; it was only after
eye trouble in the late 1890s that he turned to sculpture, first
working on small-scale terracottas (which remained his favourite
medium) and then in marble and bronze. Maillol, the son of
a fisherman from Banyuls, admired the simple, the strong,
the unspoiled; he was fascinated by the idea that the spirit of
the ancient Greeks lived on in his part of the Mediterranean and
was reflected in his work. His subject was the female nude –
full-figured, robust – symbolizing Night, the seasons, the

Mediterranean, or whatever was required in a monument. He
drew constantly from the model, occasionally from memory or
photographs.

This life-drawing is of the type of female Maillol admired,
heavy-hipped and large-limbed. His favourite drawing tools
were soft ones, black and sanguine chalks, pastel, charcoal, and
he was careful in his choice of paper, often using handmade or
coloured paper (in fact, Maillol created a type of paper called
Montval for the printing of his woodcuts as he could find none
suitable). Hence, this drawing is unusual in being on the leaf of a
German book and in pencil, suggesting that it was made
unexpectedly with what was given to him. Count Harry Kessler
(see also No. 51) was a friend and patron of Maillol, who
commissioned book illustrations from him (for Virgil's *Eclogues,*
not published until 1926), and on the strength of Maillol's
classicism took him on a voyage to Greece in 1908, stopping at
Naples and Pompeii. They collaborated together on many
occasions (and Maillol was accused of espionage in 1914
because of his association with a prominent German), so that
there is a possibility that this drawing was made for him, or as a
result of Maillol's friendship with him.

27 Edouard Manet (1832–1883)
 Odalisque
Etching and aquatint in a brownish-black ink on cream laid
 paper. There is an ms. inscription in pencil, *E.M.* lower
 right, overlapping with the platemark (not by the artist)
121 × 191 mm (image), 128 × 199 mm (platemark),
 150 × 235 mm (sheet size)
Provenance: Probably bought from Zeligmann, Paris before 1963
Literature: J.C. Harris *Édouard Manet Graphic Works*, New
 York, 1970, No. 56 (with further references)

This print, known in one state only, was not published until 1884.
Scholars disagree as to its date, for it is clearly connected with a
watercolour in the Louvre which has analogies with Manet's
preparatory drawings for *Olympia* and with the picture *Young*

woman reclining in Yale University Art Gallery, hence suggesting
an early date of 1862. However there are strong stylistic
arguments for a later date of 1868, reinforced by the undoubted
connection between the print and the painting *La Sultane*, of
1870–1 now in the Bührle collection, Zurich. Manet's prints of
the mid and late 1860s are less experimental in manner than the
large number of boldly and expressively executed etchings of
1860–2. Here the etched lines are economical and restrained,
the value of the blank paper is fully explored and the aquatint
provides a subtle tonal background; all of this points to the later
date. Harris suggests that this sensuous figure might have been a
first idea for the etching *Fleur exotique* which was commissioned
from Manet in 1868 but that Turkish-style exoticism was rejected
in favour of an image closer to Goya.

28 Edouard Manet

Portrait of Berthe Morisot

Etching in black ink on cream wove paper. There is a pinhole at each corner, possibly where the paper was secured to the plate. Below right, outside the platemark, is the ms. inscription *E.M.* (not by the artist)

117 × 79 mm (platemark), 246 × 185 mm (sheet size)

Provenance: Probably bought from Zeligmann, Paris, before 1963

Literature: J.C. Harris *Édouard Manet Graphic Works* New York, 1970, No. 75 (with further references)

The etching is derived from a portrait in oil (now in a private collection) of Berthe Morisot, Manet's friend and pupil, made in 1872, when she was in mourning – one of a half dozen portrayals he made of her between 1869–72. This was the only portrait which showed her face lit from one side, and Manet went on to explore in print these effects of light and shade. Two lithographs were also made after the portrait, one entirely linear in style, the other concentrating on the masses of light and shadow (Harris 73 and 74). The etching slightly modifies the pose

of the oil – Berthe's left shoulder (seen now in reverse) is thrown forward more in the print so that the effect is one of greater intensity. Manet may have drawn directly onto the plate, or more likely traced the image from a small-scale photograph of the painting. He first worked with long vertical strokes, avoiding delineating any contours, and in its first state the lines are widely spaced. In the second state here, all has been worked over so that the shadowing is darker throughout.

Few of Manet's prints were published in his lifetime. This image was first issued in a portfolio of 24 prints by the artist of 1890. There were two subsequent editions in 1894 and 1905, after which the plate was cancelled with two holes top and bottom. Further prints were pulled from the cancelled plate, as here, in 1910 and later: restrikes from the cancelled plate appeared in the German translation of T. Duret's *Histoire d'Édouard Manet* published by Waldmann, Berlin 1910, the English edition of 1912 and Waldmann's *Édouard Manet* Berlin, 1923. (I am most grateful to Juliet Bareau for this information.) The plate is now in the Bibliothèque Nationale, Paris.

…odigliani (1884–1920)

…aper with a serrated left edge (slightly stained …ge). Laid down. Signed below centre in pencil

…inside of aperture)

…pold Zborowski; Private Collection; Sotheby's …y 1957, Lot 42

…8

…s are rare in Modigliani's art: this very beautiful young standing figure seems to have no counterpart in any other drawings or paintings. The androgynous character of the figure (and Modigliani's apparent ambivalence as to its sex) is striking, although unsurprising from an artist whose sculpted heads could be either male or female. In the convoluted pose with the head thrown back, the sturdy outstretched arms and the clean, sweeping line of the back, the figure recalls some of Modigliani's

Caryatid studies of 1913–14 (for example, one in the Tate Gallery, T. 148). However, the very refined style of the drawing with its precise hatchings and shadings is closer to drawings of 1916. Around 1915–16 Modigliani drew a lithe, graceful male dancer (the drawing is in the Princeton University Art Collection), perhaps inspired by the performances of the Diaghilev ballet in Paris, which shares the same imaginative world as this drawing. There are some studies of male nudes in a group of drawings of 1916 which have a religious meaning (and may be connected with the conversion to Catholicism of Modigliani's Jewish friend Max Jacob) but these are of emaciated, Christ-like figures, or others beseeching, and although stylistically similar would seem to have little connection with this languid figure whose elegantly held arms direct our gaze beyond the page.

Leopold Zborowski, a Polish poet, art dealer and close friend of the artist, was one of his main patrons from mid-1916 onwards; he bought his work, organizing Modigliani's first one-man show in Paris in 1917.

30 After Amedeo Modigliani
 Reclining nude, seen from behind
Etching in black ink on imitation Japan paper (a smooth cream
 paper), laid down at each corner. The signature *Modigliani*
 on the plate, printed in reverse
99 × 149 mm (image), 104 × 154 mm (platemark),
 221 × 287 mm (sheet size)
Provenance: Purchased at the Beauchamp Gallery, London,
 1954, £5

This etching reproduces a pencil drawing by Modigliani of 1917
(J. Lanthemann *Modigliani. Catalogue Raisonné* Barcelona,
1970, No. 888). Modigliani is at his most idiosyncratic in the
drawing, using a series of free curving strokes to define a form
which combines both front and back view and yet retains a
typical elegance and refinement. It is economical, even
calligraphic, in style and the sinuous lines recall the artist's strong
interest in early Sienese painting at the time. The etching is in the
same direction as the drawing, which is not signed. Modigliani is
not known to have experimented with printmaking in his brief
lifetime (although he designed a bookplate for a friend of which
no trace remains), and in any case it would be unusual for an
artist to etch a precise copy of a drawing. The signature is more
rounded and stilted than Modigliani's own, but it could perhaps
have been carefully drawn on the plate by the artist who was
unaccustomed to the medium; there would be little reason for a
spurious signature to be in reverse. Hence Modigliani may have
approved the reproduction of the drawing, which is on fine
quality paper, and it may have been intended for an incomplete
project such as a book illustration. Or, the etching was issued
later as a facsimile in a limited edition

31 Berthe Morisot (1840–1895)
 Girl with a cat
Drypoint in black ink on cream wove paper, faded. The paper
 is a torn-off sheet, with a fingerprint in ink on the top left
 beneath the mount. Inscribed in pencil on the verso at the
 top *Berthe Morisot*
149 × 117 mm (platemark), 250 × 162 mm (sheet size)
Provenance: Unknown
Literature: J. Bailly-Herzberg 'Les Estampes de Berthe Morisot'
 Gazette des Beaux Arts Vol. 93, May–June 1979, pp. 215-
 217, No. VI

This attractive and sensitive image shows Julie, the artist's
daughter, who was portrayed in numerous paintings and pastels
by Morisot. The drypoint, which has all the spontaneity of a pen
drawing, was based on a portrait of Julie by Renoir of 1887 which
Morisot owned (now in a private collection); she also made a
pastel after the portrait. Only eight drypoints and one colour
lithograph (never printed) are known by the artist, who seems to

have experimented with printmaking around 1888–90. At the
same time her close friend the American artist Mary Cassatt, an
accomplished printmaker who had collaborated with Degas a
decade earlier on experimental graphic work, was working with
drypoint. Encouragement may also have come from another
intimate, Stephan Mallarmé, who wanted Morisot and Renoir –
also a novice in printmaking – to illustrate his prose poem *Le
Nénuphar blanc*, and there are enthusiastic references in
Morisot's letters to the project (which was however abandoned).
Her output as a printmaker may have been larger, as she refers in
her diary to drypoints or etchings after pictures by Manet which
she owned. Morisot seems to have regarded etching as a means
of studying and exploring works she admired (and possessed)
and did not pursue it after this brief period of interest.

Only a few proofs were pulled from the plates in the artist's
lifetime – Degas owned seven. The eight copper plates were
acquired by Ambroise Vollard around 1900, and later small
editions were pulled in 1904–5 and in 1921. This example is
certainly a late restrike.

32 Edvard Munch (1863–1944)

 Portrait of a woman

Drypoint in black ink on a thick wove paper. Signed lower right
 beneath platemark in pencil *E. Munch*. A minute, sharply
 incised inscription in pencil lower left, inside the platemark,
 has proved impossible to decipher

289 × 217 mm (image), 333 × 256 mm (platemark),
 595 × 440 mm (sheet size)

Provenance: Purchased from Erskine, London, before 1962

Literature: G. Schiefler *Verzeichnis des graphischen Werkes
 Edvard Munchs bis 1906* Berlin, 1907, No. 162

This beautifully drawn drypoint was probably made in 1902.
Munch first began to make drypoints, etchings and lithographs
in Berlin in 1894, going on to work in coloured lithographs and
woodcuts in Paris in 1896, and he continued to experiment with
graphic techniques. Julius Meier-Graefe published a portfolio of
eight etchings by Munch in 1895 while in the same year the
famous lithograph *The scream* appeared in *La Revue Blanche*.
Munch was also sought after as a portraitist in paint and in print
– for instance Auguste Strindberg was portrayed in oil in 1892

and in a lithograph in 1896. Munch spent a good deal of time in
Berlin between 1898 and his breakdown in 1908, returning
north in the summertime, and his work was of major importance
for the emerging expressionist movement in Germany. The
period was one of heightening emotional difficulties and
growing alcoholism but also of some success and new
friendships. In 1902 Munch's affair with Tulla Larsen ended
violently, but he met Dr. Max Linde who commissioned family
portraits, collected his work and wrote a book about him, and
was also introduced to Gustav Schiefler who began to catalogue
his prints. This portrait has been given different names: *The
Italian woman,* or *From Hopfenblüte* – the name of a Berlin café
– and it has been erroneously identified as *Frau Schwarz* whom
Munch depicted in an oil and a lithograph. However the sitter
has never been identified. She falls into a type which obviously
compelled Munch – dark hair, strong features, large expressive
eyes under heavy brows – as many of his female sitters (Aase
Norregaard, Eva Mudocci) have this look. Munch often carried a
small copper plate about with him at this time and scratched
rapidly what he observed (a photograph of 1902 shows him in
Dr. Linde's garden sketching on a copper plate).

33 Jules Pascin (1885–1930)
 Turkish girl
Pen and brown ink and watercolour on faded cream paper.
 The studio stamp is in the lower right corner. The estate
 stamp is on the *verso*
170 × 90 mm
Provenance: Purchased from Del Banco, London, 1955, £35
Colour plate p. 34

Pascin came to Paris at the end of 1905, having made a living previously in Munich with his satirical and humorous drawings for the magazine *Simplicissimus*. Like Modigliani or Chagall (also Jewish and foreigners in Paris) he did not embrace Fauvism or Cubism; instead he developed a passion for Toulouse-Lautrec whom he studied and collected, while his taste (rather like Fritz Gross's) was also for Renoir and Bonnard. Pascin concentrated on portraits and the female nude, sometimes erotically posed, while his drawings, usually of figures and groups, include subjects such as street and café scenes, and interiors of brothels. He drew compulsively, with a witty, sardonic tone and a thin, nervous line. This watercolour drawing may date from his first years in Paris between 1905 and 1910, as it is similar in style to some early watercolours (e.g. Y. Hemin *et al. Pascin Catalogue Raisonné* Paris, 1984, II, 26, 54, 166, 185) while a watercolour in Budapest (reproduced in G. Diehl *Pascin* Lugano n.d, facing p. 26) of a group of women in a harem clearly includes the same model. Pascin lived in America from 1914–20; he visited Tunisia and Algeria more than once in the 1920s, and exotic themes crop up in his work then, however it was easy to find or create buxom Turkish subjects in Montmartre long before that.

34 Pablo Picasso (1881–1973)
 Portrait of Apollinaire
Deep pink crayon on slightly faded buff paper. Signed *Picasso*
 (underlined) top right in crayon, *verso* inscribed *Alex
 Maguy – 30 – 3.12.59* in ink
251 × 168 mm
Provenance: Purchased Galerie de l'Ile de France, Paris, £272,
 probably in the 1960s
Colour plate p. 26

Guillaume Apollinaire (1880–1918) poet and art critic, met
Picasso around the end of 1904 and the two became close
friends. Apollinaire was the first to write appreciatively of
Picasso's work in two reviews of 1905 and to call the attention of
the Parisian public to this new talent. The artist made a series of
rapid portrait studies of him in that year, to which this drawing
probably belongs. Apollinaire is invariably shown puffing on a
pipe or cigar, while his heavy jowls and walrus moustache lend
themselves well to caricature: even the straightforward studies
verge on the irreverent. Three cartoons (in pen and ink) similar to
this one are known, although there are small variations between
them; there is another one of Apollinaire as the Pope – the same
egg-head with a pipe, this time full-length, enthroned in papal
regalia. Picasso also designed an amusing book-plate for his
friend in 1905, where Apollinaire is shown at table royally
crowned, raising a goblet to drink[1].

[1] See C. Zervos *Pablo Picasso* Vol. I, 225 (the bookplate); XXII, 289-294 are all
caricatures, in ink or in pencil. The Pope caricature is reproduced in *Pablo
Picasso 1881– 1973* ed. J. Golding and R. Penrose, Wordsworth Editions 1988,
fig. 283. For other portrait drawings of Apollinaire of 1905 and 1916 see
Zervos VI, 728, 1324; XXIX, 200 and XXII, 287, 288.

35 Pablo Picasso
Femme et l'artiste (Woman with the artist)
Pen, brush and Indian ink on cream wove paper. Laid down.
 Signed and dated in ink upper left *Vallauris le 24.12.53/*
 Picasso (underlined)
345 × 260 mm (inside of aperture)
Provenance: Purchased Sotheby's Sale 12th October 1960,
 Lot 28, £1100
Exhibitions: London, Marlborough Gallery, 1955 *Picasso
 Drawings and Bronzes* No. 12; New York, Saidenberg
 Gallery, 1955–6 *55 Drawings by Picasso* No. 7
Literature: *Verve* Vol. VIII. No. 29 and 30, plate 22; M Leiris and
 R. West *Picasso's Private Drawings* New York, 1954, repr.,
 n.p; C. Zervos *Pablo Picasso* Vol. XVI, Paris, 1965, No. 81

Aged 72, just after Françoise Gilot had left him, taking their two
children, Picasso executed a series of drawings – some comical,
some touching – on the theme of the making of art, and the
artist's lot. There were 180 in all produced over nine weeks from
November 28th 1953, each one dated (and the series can be read
like a diary). The drawings were subsequently published in the
magazine *Verve* in chronological order.

The series begins with the artist and his model – she is
relaxed while he admires; she looks dubiously at him at work;
she smirks at a fat naked artist or looks kindly down at a small
ridiculous clothed figure; elsewhere she is beautiful but
unmoved by the artist playing with a mask, or she poses,
indifferent, while a crouched bespectacled artist scribbles or a
more handsome, intense figure paints before critics and
bourgeois patrons. There are some marvellous scenes where a
masked Cupid plays with a model whose calm pose rapidly
changes to a twisting, laughing one; there are also circus scenes
with pierrots and clowns before the series returns to the artist's
studio. This drawing comes relatively early in the series, which
has also been called *The Human Comedy.*

Picasso uses both pen and brush dipped in black ink, so that
details such as the model's chunky necklace (her only item of
apparel) or the artist's old hat, pushed back in his anxiety (and
revealing his bald head) are rendered with great freedom, as is
the dark shadowed area against which his head is silhouetted.
The drawing is made fluently and economically – the diagonal
support of the easel for instance can later be read as the back of
the model's right knee.

36 Pablo Picasso
 Les Trois baigneuses I (Three bathers I)
Drypoint on a zinc plate in black ink on cream paper
176 × 130 mm (platemark)
Provenance: Unknown
Literature: B. Geiser *Picasso Peintre-Graveur* 2 vols, Berne,
 1955, I, No. 106; G. Bloch *Pablo Picasso* 4 vols, 4th ed.,
 Berne, 1984, I, No. 60

Picasso's apparently effortless draughtsmanship is on view here;
the clear contours drawn on the zinc plate are confidently incised
in continuous lines, and the occasional traces of burr on chin,
arm or hand add richness and relief to the image.
 This drypoint was made in 1922/23 at a time when Picasso
was interested in the theme of bathers, or groups of nudes by the
sea, and also in that of the Three Graces where female bodies are
rhythmically intertwined in a circular movement and an ideal of
female beauty is expressed. The artist makes some formal play
here with the relationship of the three heads (looking up in
profile, across at the viewer in full face, or down in three-quarters
profile) and of the three visible breasts and the two sets of three
hands. Perhaps as part of this visual game he has introduced an
extra hand – the central figure has her right hand resting both on
her companion's shoulder and around her waist. The combination
of black ink, pale grey plate tone and white margin is an
extremely effective one, evoking as a middle tone the colour of
flesh and of the sea.

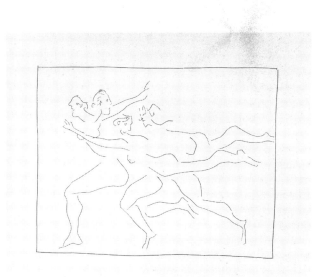

37 Pablo Picasso

Quatre femmes en fuite (Four women in flight)
Etching in bistre ink, with remarque in black ink, on Rives paper
135 × 170 mm (printed border), 325 × 263 mm (sheet size)
Provenance: Purchased Sotheby's Sale 8th April 1959,
 Lot 77, £30
Literature: B. Geiser *Picasso Peintre-Graveur* 2 vols,
 Berne 1955, I, No. 161b; G. Bloch *Pablo Picasso* 4 vols,
 4th ed., Berne 1984, I, No. 117; P. Cramer, S. Goeppert and
 H. Goeppert-Frank *Pablo Picasso. The Illustrated Books.*
 Catalogue Raisonné Geneva, 1983, No. 19 and p. 239

Picasso was a prolific illustrator, being involved over his career in 156 publications. His first major project was for Albert Skira who set up as a publisher in Lausanne in 1928; Picasso promised to design 15 illustrations for Skira's first book, and the choice was that of Ovid's *Metamorphoses* after Picasso had recounted his dreams of women turning into fish. The etchings were made from September 1930–1931, and include the original agreed 15 as title pages for each book, with a subsequent 15 as smaller chapter-headings. The book was printed in October 1931 (with the etchings printed by Louis Fort) and issued in 145 signed copies; Picasso and Skira went on to collaborate on many other projects. A small number of proofs were separately printed,

including two on Rives paper with the main design in bistre and the remarque (see below) in black as here.

Picasso's designs are strongly classical in spirit – clear, linear, with profiles preferred, restrained, and carefully composed so as to give the effect of a bas-relief sculpture. But they are full of movement and wit. Here Picasso is extremely economical with his line, as the centre area is practically blank, and there are only two arms and six legs visible in all; yet because of the way the profiles are counterposed, and the way the legs fan out, an impression of fast, headlong movement with conflicting reactions is effortlessly attained. This image was the 19th illustration in the book, and comes at the beginning of Book X, p. 239, where a sorrowful Orpheus comes into view, mourning the death of his wife Eurydice who, while accompanied by her Naiads, was fatally bitten by a serpent – hence the flight in horror of the Naiads.

A 'remarque' is a design made on the plate outside the main image, and its original function was to test the strength of the acid in the etching process, but it was usually burnished away. By the late 19th century it was fashionable to print a remarque as a counterpoint to the 'real' subject. Picasso's scribbled, shadowed female head refers to this tradition while providing a complete contrast in colour and style to the clean lines and flat stylized contours of the book illustration.

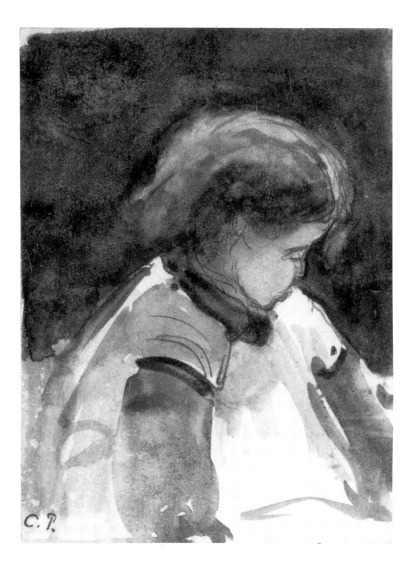

38 Camille Pissarro (1831–1903)
 The artist's daughter, Minette
Pencil and watercolour on white paper. The estate stamp, *C.P.*
 lower left
155 × 110 mm
Provenance: Lucien Pissarro; Orovida Pissarro; John Rewald;
 purchased Sotheby's Sale 7th July 1960, Lot 86A, £450
Colour plate p. 33

Jeanne-Rachel, known as Minette, was born in 1865, the second child of Camille Pissarro and Julie Vellay (their first-born was Lucien, 1863–1944); she died at Pontoise on 6th April 1874, aged nine. Pissarro often drew and painted Minette and also made a lithograph of her on her deathbed[1]. This watercolour is an affectionate study of her as a very small child, made probably in 1867, and it seems to be the earliest portrait of her. At that time the family lived at l'Hermitage, Pontoise, where Pissarro concentrated on exploring landscape – developing structured compositions in the tradition of Corot, Courbet and Daubigny – and exhibiting at the Salon. During Minette's short life the family

were to flee from the Prussian advance and spend six months in London (Camille and Julie married in Croydon in June 1871), the first of their important connections with England.

In this watercolour, Pissarro concentrated in the initial pencil sketch on getting the child's head and profile absolutely right, working more or less in the centre of the page. Her shoulders were rapidly defined in a few strokes, while her hair and the rest of her body were sketched with the brush. In the top left corner there are some indications of another small drawing on the page underneath the grey watercolour. Orovida Pissarro, Lucien's daughter, gave this sketch to John Rewald as a wedding present in 1956, and in writing to thank her he mentioned that he had found a fine old frame for it, which it retains[2].

[1] Amongst the identified portraits of Minette are P & V 192, 193, 197, 232, and 289, all of 1872–4; there is a watercolour in the Ashmolean Museum (Brettel and Lloyd No. 70) of 1870–1; see Delteil No. 129 for the lithograph dated 3rd February 1874.
[2] Letter of May 15th 1956 in the Pissarro Archive, Ashmolean Museum.

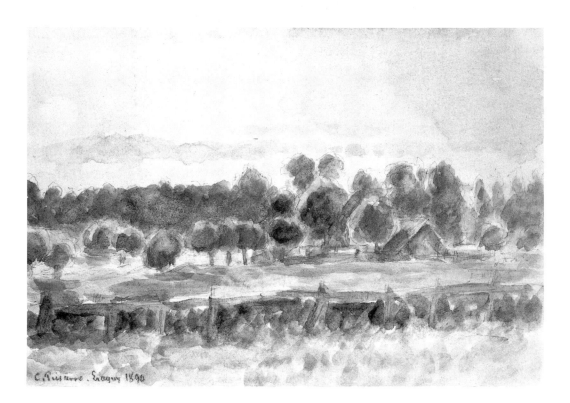

39 Camille Pissarro
 Landscape at Eragny
Watercolour over pencil on white paper. Signed lower left in
 black chalk *C. Pissarro. Eragny 1890*
175 × 252 mm
Provenance: Purchased through Jarray, Paris, Hôtel Druout,
 8th June 1954
Colour plate p. 19

Pissarro made numerous watercolours in 1890 of familiar scenes
around Eragny-sur-Epte which display his interest in the effects
of weather, season and time of day – some carry annotations and
more precise dates. He had only recently moved away from the
pointillist style which he had enthusiastically explored from 1886
in response to Seurat's innovations – Pissarro was the first to
follow Seurat in this new technique. However his dealer Durand-
Ruel had refused to sell his pointillist work, so that Pissarro was
under severe financial strain, but most of all he had found the
technique too rigid – he said it made it impossible for him to be
true to his sensations. Watercolour sketches made directly from
nature like this one provided a means of reasserting his strengths
as an artist. Pissarro's correspondence reveals his anxiety to study
nature afresh and to build up a solid vocabulary. He did not work
on any large canvases at this time, although the results of his
studies can be seen in some paintings of 1892–5 (for example
P & V 775, 782, 868, 897, 908).

40 Camille Pissarro
 Église et ferme, Eragny (Church and farm, Eragny)
Coloured etching on white paper. Signed below the platemark
 on the left with the stamp *C.P.* Numbered *10/11* in pencil
 lower right
154 × 243 mm (platemark)
Provenance: Orovida Pissarro; purchased at Sotheby's Sale
 8th April 1959, Lot 240
Literature: Delteil No. 96; J. Cailac 'The Prints of Camille
 Pissarro. A Supplement to the Catalogue of Loys Delteil'
 Print Collector's Quarterly Vol. 19, 1932, p. 81; London,
 Hayward Gallery, Paris, Grand Palais and Boston, Museum
 of Fine Arts, 1981, *Pissarro* No. 185 (for a revision of
 Delteil's dating)
Colour plate p. 18

This print is from a small posthumous edition of eleven made at
the request of Pissarro's family in 1930 by the professional printer
Alfred Porcabeuf, of which the first impression was reserved for
the Bibliothèque Nationale, together with the copper plate.
 Pissarro printed his own plates in very small editions —
typically, once he was thoroughly interested in the complexities
of printmaking he would work for himself through every stage
from idea to printed proof. The real impetus to his printmaking
had come in 1879 when Degas encouraged him to experiment
with etching and to explore unconventional techniques — at that
time he and Mary Cassatt were working closely on prints, with
Degas attempting to launch a journal of original prints, *Le Jour et
la nuit*. Pissarro tried his hand at colour printing during this
period of collaboration. But it was really only in 1894 when he
obtained a good press of his own that Pissarro worked on colour
etchings — he made only five altogether. This one, of 1894–5, is
based on a painting of 1891 (P & V 766) while the same view of
Eragny from a lower angle can be seen in two paintings of 1884
(P & V 630 and 642). In 1895 Pissarro painted the exact same
view as the print, composed in the same direction (P & V 929),
perhaps after having made the print.
 Preparatory to the etching, Pissarro made a charcoal
drawing (now in the Metropolitan Museum, New York). Then he
worked the etching through six states, in black line only. An
impression of the final state coloured over in pastel (now in the
Art Institute, Chicago) would have provided a guide for the
colour printing. Three plates of red, yellow and blue were printed
over a key plate with the original design in black, brown or grey;
the accurate superimposition and blending of colour provided a
technical challenge. Different effects of colour and tone were
obtained by variations in the inks, and Pissarro strove to achieve a
delicate blend of colour whereby a golden light would suffuse
the scene. The later printing cannot therefore reproduce the
master's original intentions, as only he was in complete control
of the entire process.

41 Pierre-Auguste Renoir (1814–1919)
Après le bain (Bather)
Oil on canvas
235 × 185mm
Provenance: Private collection, Paris; purchased from
 Marlborough Fine Art, 1949, £300
Colour plate p. 35

This attractive oil sketch with its rainbow hues was made late in Renoir's career, possibly soon after 1900. By then, he was spending much time on the Mediterranean coast and had returned wholeheartedly to a Classical ideal of painting the nude figure in a timeless setting. The theme of the bather, a single female nude in a landscape, was one which preoccupied him from 1881 when he had moved away from Impressionist aims of conveying the effects of dappled sunlight breaking up solid forms into a myriad of touches. Instead, in many of the later *Bathers* the figure stands out clearly from a sketchily-indicated leafy or grassy background, and is firmly and solidly depicted. Renoir had always loved French 18th century painting, especially the soft, loose handling of Fragonard, while in his wide travels in the late 1880s and 1890s he renewed his interest in Titian, Rubens, Veronese and Rembrandt – all masters of painterly brushwork, and of the female nude – and these preferences come to the fore in his late work.

Renoir continued to paint out of doors at this time, although declining health brought him more and more indoors. He hated inactivity, and when he found it hard to concentrate on large pictures he turned to quick sketches like this one, independent works happily thrown off. His models in the 1880s and 1890s tend to be young and girlish, softly painted in a wide range of colours (in the mid 1890s Renoir said he had restored black to his palette), while by the early 1900s his models are more voluptuous, even massive, and the tonality is hot, with reds and pinks predominating as though he were capturing southern light and temperature.

42 Pierre-Auguste Renoir

 Le Chapeau épinglé (Two girls; or, The hat secured with
 a pin)

Etching and drypoint in black ink on buff paper.

 Signed on the plate lower right *Renoir*

115 × 81 mm (platemark)

Provenance: Unknown

Literature: Delteil No. 6

Renoir began printmaking late in his career, around 1890 when
the revival of interest in artists' original prints was well under
way, and his prints of that decade tend to reproduce his own
paintings and drawings. He made some large colour lithographs
which were very popular, including two of this subject in 1898.
He also etched three different plates of *Le Chapeau épinglé* of
which this is a print from the first, in its only state, drawn in 1894.
The models were Berthe Morisot's daughter Julie (see also No.
31) and her cousin Paulette Gobillard. The etchings and the
lithographs were derived from a pastel known as *The flowered
hat* of c. 1893.

 The plate, together with No. 43, was published in T. Duret's
Manet and the French Impressionists London 1910, and it also
appeared in the German edition, Berlin 1914.

43 Pierre-Auguste Renoir
 Baigneuse (Bather)
Etching in black ink on faded white paper
165 × 106 mm (platemark), 248 × 164 mm (sheet size)
Provenance: Purchased Sotheby's Sale 26th July 1966,
 Lot 59, £16
Literature: Delteil No. 23

Renoir was not a prolific nor an innovative printmaker, however in his second burst of interest in printmaking after 1905 he experimented with soft-ground etching, and made some very fine original lithographs for an album commissioned by Ambroise Vollard. As in his painting, the theme of the *Bather* (see the comments at No. 41) was explored; this type, of a girl covering herself like a *Venus Pudica* as she emerges from the water, first occurs in a painting of 1888, *La Sortie du bain,* in the Cleveland Museum of Art. Renoir drew with great freedom the movement of the water and the long grass, and his differentiation of the girl's body from the water between her arm and waist is most attractive.

This etching together with No. 42 was first published in 1910, in Duret's *Manet and the French Impressionists;* it also appeared in subsequent French editions of 1919 and 1923.

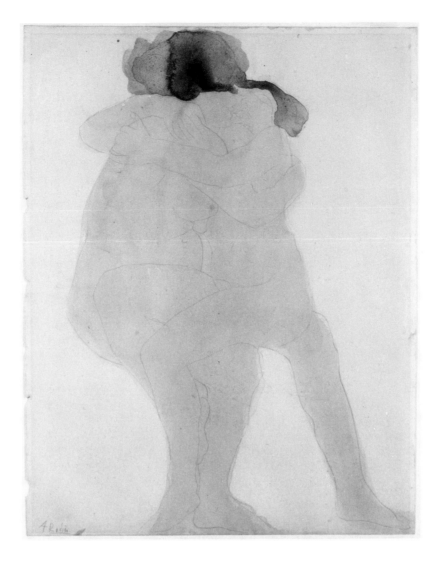

44 Auguste Rodin (1840–1917)
 The embrace
Pencil with watercolour on cream paper (with jagged edges on
 left). Signed in pencil lower left, *A. Rodin*
325 × 249 mm
Provenance: Purchased from Agnew & Co, London, 1957, £25
Exhibitions: London, Hayward Gallery, 1986 *Rodin Sculpture
 and Drawings* No. 178 and pl. 258; catalogue by
 C. Lampert
Colour plate p. 23

This drawing probably dates from around 1904. By then, Rodin
was famous, weighed down with honours and public duties,
supervising the activities of a large atelier. His own creative
energy was expressed in small-scale works, portrait busts, and
drawings such as this one. He had always drawn constantly, not
in preparation for sculpture but as a means of studying the
human body, setting down ideas, or recording observations, and
he kept his drawings for reference and for re-use – sometimes
tracing over them, correcting and annotating them, or even
cutting out shapes so as to start afresh. By the end of the 1890s
he worked almost exclusively from the model; such was his hard-
won experience that he did not necessarily even look at the
paper while drawing, but would set down large, rhythmical
contours on the page while keeping his eyes on his subject. His
late drawings, almost entirely of the female nude, are often of
abandoned, uninhibited poses suggesting themes of sexuality
and fertility. This drawing is one of a group of studies of female
couples; the pencil line creates superb continuous contours
while the muted wash endows warmth and solidity to the forms.

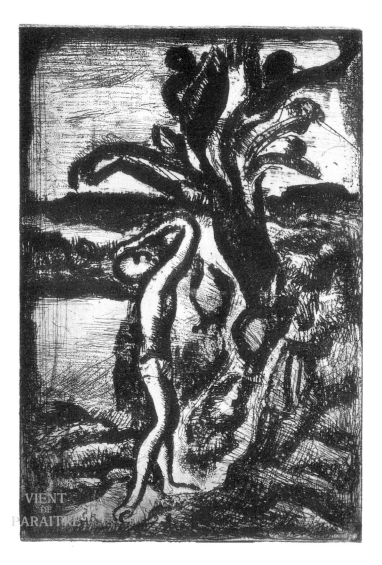

45 Georges Rouault (1871–1958)
Frontispiece for 'Les Réincarnations du Père Ubu'
Etching, drypoint and aquatint in black ink on thick cream
 paper (watermark: Ambroise Vollard). Signed and dated
 lower left *1918 G.R.* partially obscured by the red stamp
 Vient de Paraitre (Appearing Soon)
293 × 195 mm (platemark), 296 × 196 mm (entire image),
 438 × 320 mm (sheet size)
Provenance: Purchased from A. Simmonds, 1961
Literature: F. Chapon *Oeuvre gravé de Rouault* Monte Carlo,
 1978, No. 8. See also Johnson No. 199; Boston 1961
 No. 270

This is an early proof of the frontispiece, in its fourth and final
state, used to advertize Ambroise Vollard's forthcoming
publication of *Les Réincarnations du Père Ubu*. Rouault began
work on the illustrations – 22 etchings and 105 wood-
engravings – in 1916 and completed them by 1928; the book
was printed in 1932 in 335 numbered copies.
 Alfred Jarry's satiric farce *Ubu Roi* was first privately
performed in 1888; its Parisian début was in 1896 with sets

painted by Bonnard and Sérusier. Vollard was fascinated by the
belligerent and anarchic figure of Père Ubu; he and Jarry
developed this character further in a series of *Almanachs* and
Vollard continued to expand Ubu as a villainous Fool, with the
Réincarnations as his most ambitious project. It was an
anthology of comic and satirical dialogues – Ubu's Colonial
Policy, Ubu at the Front, Ubu in Soviet Russia. Neither Dérain nor
Forain were interested in illustrating it, and luckily Vollard came
to Rouault. His vocabulary had been one of clowns, prostitutes
and outcasts – not unusual for its time, but they were painted
with a disturbing, almost visionary, intensity. In Rouault's hands
the monstrous and ridiculous Ubu became a more sinister and
haunting figure. The artist was allowed great freedom to weave,
as he said, a kind of fantasy around Père Ubu. The illustrations
were given equal value with the text, and in the case of the
etchings were to be found loose in a folder with the explanation
that the readers could create their own arrangement of images.
The frontispiece is echoed in a second plate where the figure is
black, and is related to the text at p. 62. There the President of
the League of Nations asks Ubu about Negro courtship, and
Ubu's answers grow more absurd as his gullible audience

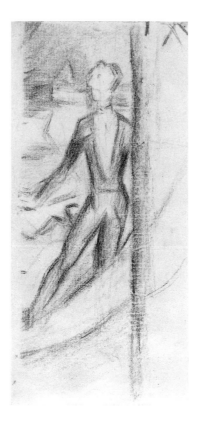

swallows them wholesale – here he describes how local Romeos call to their Juliets who have taken themselves to the treetops and will only come down for a price.

Rouault may have been somewhat daunted by his first major incursion into printmaking (although he was to go on to illustrate further books for Vollard) especially given the technical difficulty of translating his gouache sketches into print. For the majority of the etchings, the basic image was first transferred to the copper plate by a photographic process known as photogravure, and the artist then worked over the plate. However, photogravure was not used in the case of this and six other plates. Instead Rouault first etched the main lines of his design, then over three further stages explored every possibility his tools and the plate could offer so that a rich, many-layered texture was achieved.

One can see from this print how the plate has been thinly scratched in some parts of the sky and earth to provide delicate shadowing; the roulette (or patterned wheel) has been played over it extensively (notice the stippled effects of the sky on the left) to provide texture in the shadows; many of the darker horizontal and vertical hatching lines are etched on the plate, while there are furious workings in deeply-engraved drypoint; the velvety feel and the 'burr' left by the uneven edges of the copper lines are particularly strong. Aquatint has been extensively used, together with burnishing, to provide dark-toned areas, lending a sense of boldness and impetuousity to the image.

46 Georges Seurat (1859–1891)
Clown and Monsieur Loyal (Study for 'Le Cirque')

Conté crayon on cream Ingres paper with Michallet watermark. Some inscriptions on the *verso; Seurat* and *373 bis* in blue crayon; in pencil *Ingres gris/l'autre (or l'antre)...bleu (or blanc)/laque bleu*

314 × 153 mm

Provenance: Felix Fénéon (Lugt Suppl. 924a); sold Paris, Hôtel Druout 12th March 1943 and again 31st March 1944; Wildenstein & Co. New York 1959; Dr. W. and Mrs. H. Munsterberger, New York; Sotheby's Sale 23rd June 1965, Lot 36

Exhibitions: Wildenstein, New York, 1953 *Seurat and His Friends* No. 38

Literature: H. Dorra and J. Rewald *Seurat* Paris, 1959, No. 210b; C.M. de Hauke *Seurat et son oeuvre* 2 vols, Paris, 1961, II, No. 708; R.L. Herbert *Seurat's Drawings* London, 1962, No. 171

This is one of six known drawings for *Le Cirque* of 1890–1, now in the Musée d'Orsay, which was Seurat's last major painting. He exhibited it not entirely finished at the *Independants* show of 1891, and fell fatally ill a few days later. The subject was of the popular Cirque Fernando, which figured also in the work of Degas and Toulouse-Lautrec. Clowns and acrobats appeared in Seurat's drawings from around 1881, while *Le Parade* of late 1887 had dealt with the fairground in a coolly theoretical manner. *Le Cirque* represented a new departure for Seurat as a dynamic composition of movement and action in deep space,

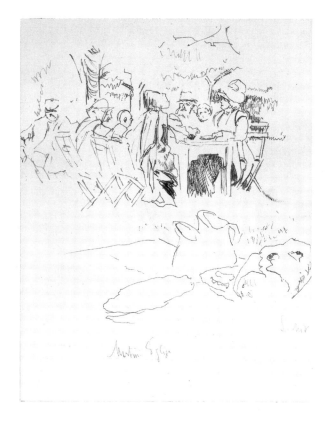

which was also extremely decorative, full of surface patterning and with a broad painted border.

Conté crayon was one of Seurat's favourite techniques, and when used on thick paper as here, with the grain showing clearly, its tonal range expands. The preliminary drawings study individual figures and groups; Seurat's concern here is with establishing the exact position of the ringmaster, M. Loyal. In the final composition he is in a very similar position, cut off on the right by the painted border and below by the streamer which a large foreground clown holds, although the stance of the clown behind him has been altered. M. Loyal's moustache is accentuated in the painting, sweeping sharply upwards in keeping with the directional lines of the composition, which according to Seurat's theories would evoke verve and gaiety.

The number and name on the *verso* were probably written when Signac, Luce and Fénéon were making an inventory of Seurat's studio after his death. The pencil inscription is quite likely to be in the artist's hand. *Ingres gris* seems to refer to a type of paper. If one reads *l'antre,* which means a cave or den, there may be a reference to the entrance to the circus ring behind M. Loyal which is not defined in the drawing. With a reading of *l'autre* the inscription becomes a colour note; *the other (. . .) blue/white* and below *blue lake,* perhaps referring to the colour of the painted border or to M. Loyal. (I am grateful to Richard Thomson for these suggestions.)

47 Walter Richard Sickert (1860–1942)
Eating pancakes

Pen and brown ink on white paper. Signed in pencil lower right, *Sickert,* and inscribed by the artist in pencil below centre *Martin Église.* A streak of black crayon on the right of the sheet
380 × 275 mm
Provenance: Purchased London, Piccadilly Gallery, 1955, £9.10s

Sickert's first recorded visit to Dieppe was in 1885; he went back there every summer until the War, lived there from 1898–1905, and bought a villa at nearby Envermeu in 1912. In Dieppe, the artist was a close friend of Jacques-Émile Blanche while he kept up his acquaintance with the Parisian art world (he had a one-man show there in 1904, and exhibited at the Salon d'Automne from 1905–9), providing an important link between the French and English avant-garde. This delightful informal sketch was made in the garden of the restaurant Clos Norman in Martin Église, a village near Dieppe, which was a favourite haunt of Sickert. The drawing probably dates from 1913–14, and seems to include in the bearded man a self-portrait – Sickert was proud of his newly-grown beard in 1913. At that time the owner of the restaurant was Victor Lecour (see No. 49 below). I am indebted to Dr. Wendy Baron for her helpful suggestions regarding this and the following two drawings.

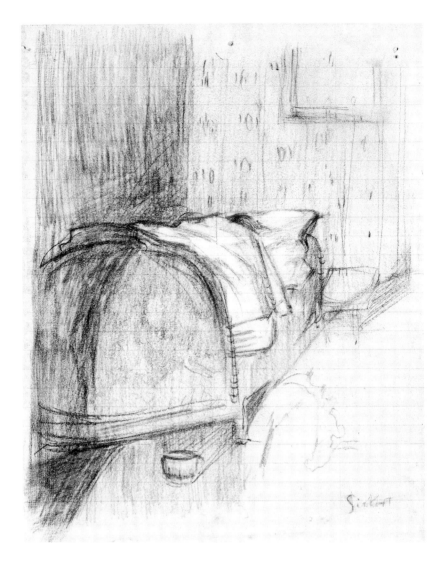

48 Walter Richard Sickert
Bedstead
Black chalk (some areas reworked and strengthened with
 charcoal) on a page from a ruled notebook. Pinholes at top
 left, centre and right. Inscribed lower right *Sickert*
220 × 170 mm
Provenance: John Wheatley; Christie's Sale 11th November
 1958, Lot 18; Bonham's; Piccadilly Gallery from whom
 purchased in 1960

Sickert was a prolific draughtsman, and he often returned to his
drawings later to use them as sources for paintings, to re-work
them or merely to give them a signature. This intimate sketch of a
long-haired woman hidden beneath piles of blankets is made on
a page from a notebook. It is not directly related to a particular
painting; however Sickert would make quantities of notes of a
subject which interested him (and sometimes he would paste
together a mosaic of small sketches preparatory to the final
painting). Dr. Wendy Baron suggests that in its handling and
detail, such as the chamberpot under the bed, this drawing may
have been made around 1907–9, close to the Camden Town
Murder series in which beds and bedsteads play a major role. This
was a group of drawings and paintings, inspired by a local
murder of a prostitute, showing close-ups of bedroom scenes
with a man and a woman (who is generally nude). Other works
around the same time explore the theme of couples or women
alone in bedrooms; these domestic scenes evoke the drabness of
everyday working-class life. Sickert made bedroom studies again
notably around 1920–22 in Dieppe, and in mood this drawing is
perhaps closer to that later group. It once belonged to the
collection of John Wheatley, a pupil of Sickert's during the First
World War period.

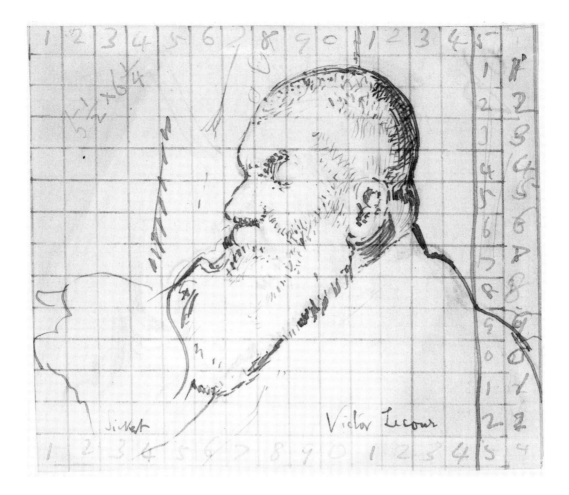

49 Walter Richard Sickert
Victor Lecour

Pen and brown ink over rubbed indications in pencil, on buff
paper partly washed over. Squared up in red ink with the
squares numbered on three sides; $5\frac{1}{2} \times 6\frac{1}{4}$ in red ink
upper left. Signed *Sickert* in brown ink lower left, and
Victor Lecour inscribed by the artist to the right. On the
verso inscribed in red ink *reduce to /5¼ × 3⅛/ and reverse*
140 × 161 mm
Provenance: Bought at the Beaux Arts Gallery at an unknown
date, £4

Victor Lecour sat for a portrait in 1922 in Sickert's studio at the
Rue Aguado, Dieppe (now in the Manchester City Art Gallery).

There he is shown as a large, bald man with a full beard standing
against the light, but there is no connection with this drawing.
Sickert wrote of Lecour, whom he knew well (see No. 47), that he
was 'a superb creature – like a bear', and he certainly portrayed
him a number of times. This drawing would appear to be for a
lost portrait, possibly one of the two sold at Christie's on 30th
November 1928, Lots 101 and 103. Sickert's working methods
when it came to producing portraits were streamlined in his
maturity; from 1914 onwards the squaring-up of preliminary
studies such as this, the transfer to canvas and the laying-on of
tonal underpainting was largely left to assistants, and the
instructions such as those on the *verso* of this drawing would
have been commonplace.

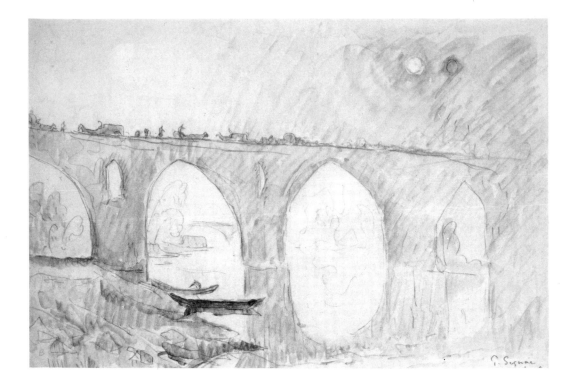

50 Paul Signac (1863–1935)
The bridge at Montauban
Watercolour over black chalk on white paper. Signed *P. Signac/*
Montauban lower right
252 × 372 mm (inside of aperture)
Provenance: Private collection; Leicester Galleries; purchased
 Piccadilly Gallery 9th December 1966
Colour plate p. 17

Paul Signac is probably best known as an avant-garde artist of the mid-1880s and 1890s, a friend of Seurat and a leading Neo-Impressionist (see No. 51). After 1904 however the rigorous rules of painting he espoused were gradually replaced by a more free and dashing style, following the example of the Fauves (Matisse, amongst other friends, painted with him in St. Tropez). Most of his subjects are of rivers and the sea, boats, bridges and harbours. Signac was a fervent yachtsman as well as a painter and art critic; he had no formal training at the outset but was greatly influenced by Manet and later Pissarro – on the prow of his first boat in 1882 he painted his galaxy of names: Manet, Zola, Wagner. He was widely travelled and painted in many of Europe's great ports – Rotterdam, Marseilles, Venice, London.

Signac's output in watercolour is large, and his interest in the vigorous, airy style of Jongkind (on whom he published a book in 1927) has been noted. This drawing was first freely sketched – loose hatching strokes are used for the sky and bridge while the riverbank is strongly massed with thick zig-zag strokes, and the more distant elements are lightly, almost abstractly sketched. The colour range is deliberately limited to green, dark blue, mauve and pink evoking a watery, winter early morning light. The position of the sun was altered – it was originally drawn a little smaller in size further to the left. Signac did another view of the bridge at Montauban in December 1912, now in the Los Angeles County Museum.

Fritz Gross was obviously anxious to purchase this watercolour; according to the family records, in addition to paying £150 he exchanged a Klimt and a Beckmann in order to obtain it.

51 Paul Signac
 Le Soir (Evening)
Colour lithograph, printed in five colours (pale yellow, pink,
 green, light blue and a darker blue) on Chine volant paper
 (a thin greyish handmade paper)
202 × 261 mm (plate), 260 × 333 mm (sheet size)
Provenance: Purchased in Paris, 1954
Literature: E.W. Kornfeld and P.A. Wick *Paul Signac* Berne,
 1974, No. 20, II e
Colour plate p. 40

This colour lithograph was published in the German avant-garde
magazine *Pan* of 31st July 1898, an issue which was a showpiece
for Neo-Impressionists as it also contained colour prints by
Maximilian Luce, Henri-Edmond Cross (see No. 9), Theo van
Rysselberghe abd Hippolyte Petitjean. Signac's print is based on
his painting *Le Jetée de Flessingue* of 1896 (now in a private
collection, Lausanne).

 On 29th December 1897 Signac noted in his diary that a
young German connoisseur (Count Harry Kessler) had asked him
for a lithograph for *Pan*[1]. They met again over the next few days;
Signac was impressed by Kessler's sensitivity as a connoisseur,
and the German bought an oil painting and some watercolours
(' ▪ knew well to choose the best' wrote Signac) while also
purchasing on Signac's advice *Les Poseuses* by Seurat. That
autumn there was a major Neo-Impressionist exhibition in Berlin
organized by Kessler; Signac wryly noted that the Berlin public
took the work seriously, while in France the painters were merely
sneered at. Signac's first few attempts at printmaking took place
between 1885–8, with his first colour lithograph (in nine

colours) a cover design for a theatre programme of 1888 which
was innovative in the application of Neo-Impressionist colour
theories to lithography – it advertised Charles Henry's *Chromatic
Circle*[2]. However it was not until 1894 that he began to develop
this initial experiment – and the scientific terminology is
appropriate as the artist was relentless in his pursuit of exact
colour effects. His working methods were meticulous and
painstaking in producing a print such as this. On a preliminary
colour sketch he would place a sheet of transfer paper and
outline the contour of every touch of the same colour so that a
full colour-map was produced. He would also make a separate
transfer sheet for each of the colours (five in this case) which
would be transferred to the prepared lithographic stones. The
master-printer Auguste Clot carried out the printing; the tiny
pin-holes with which the paper had to be fixed so as not to slip
during successive printings can be seen. Signac would then
correct and annotate the trial proofs with precise directions for
the printer to follow. The effects he sought were subtle indeed –
here the way in which the light of the setting sun reflects through
the clouds on moving water and transforms the colours of boats
and jetty – and one would have thought practically impossible
with five printing inks on pale grey paper. Yet Signac's attention
to the minutest detail of shape and colour has ensured that a
sense of dancing movement and a myriad-coloured light has
been achieved.

[1] J. Rewald *Gazette des Beaux Arts* Serie 6, Vol. 39, April 1952, pp. 271-3.
[2] See P.D. Cate and S.H. Hitchings *The Color Revolution: Color Lithography in
 France 1890–1900* Rutgers University Art Gallery, 1978, No. 147 and fig. 51.

52 Alfred Sisley (1839–1899)
 Bords du Loing (The banks of the Loing)
Lithograph in maroon ink on cream paper. Signed *Sisley* in
 pencil below right, and inscribed in pencil below left *epr.
 d'essai.* Signed and dated on the plate *Sisley 96* lower left
142 × 222 mm (plate), 252 × 324 mm (sheet size)
Provenance: Purchased from the Redfern Gallery, London,
 22nd November 1958
Literature: Delteil No. 5

This is a rare trial proof for the lithograph which was first
published by Roger Miles in *Art et nature: études breves sur*
quelques artistes d'hier et d'aujourd'hui in 1897, illustrated by
artists' prints including work by Boudin, Gustave Moreau
and Pissarro. It was printed in black ink there and in its
subsequent publication in Theodore Duret's *L'Histoire des
Peintres Impressionistes* of 1906.

Sisley made only four etchings and two lithographs (the
second was in colour, published by Ambroise Vollard in an album
of 1897), all of riverside views near his home at Moret-sur-Loing.
A number of paintings of 1896 show the same view as in this
print (including one in the Ashmolean, A479) although
foreground details differ. Sisley was essentially a landscape artist,
and was happiest working on splendid skies and water.

53 Théophile-Alexandre Steinlen (1859–1923)
　　Deputé
Colour photorelief. Signed on the plate *Steinlen* lower left.
　　The number 30 in pencil lower right
318 × 149 mm (irregularly cut)
Provenance: Unknown
Literature: E. Crauzat *L'Oeuvre gravé de Steinlen* Paris, 1913,
　　p. 180, No. 50

This appeared in *Gil Blas illustré* of 11th December 1892,
illustrating a song by Maurice Boukay, with music by Georges
Tiercy. The song is of a rural parliamentary deputy, elected (with
quantities of beer to celebrate) on the strength of increasing
everyone's salaries, whose moment of triumph comes here when
he insults the President who has ordered him to be quiet, and he
is expelled from the chamber. Steinlen contributed to numerous
illustrated journals such as *Le Mirliton* or *Chambard Socialiste*
while he designed over 400 lithographs for *Gil Blas:* his subjects
ranged from political comment to satire and comedy. The colour
photorelief process made use of photographic methods for
preparing the printing plate (which could be printed with the text
on a typographic press) rather than the artist's or engraver's
hand, but the two still had to work very closely together and the
proofs would be corrected by the artist.

　　Crauzat records another illustration for the same song in an
advertisement of June 1892 (No. 409, repr. p. 114), where the
deputy stands fiercely alone.

54 Théophile-Alexandre Steinlen
Convoitise (Covetousness)
Crayon lithograph, with a beige colour plate on white paper.
 Signed on the plate lower right, and signed below the
 main image in pencil *Steinlen*. The paper carries the stamp
 Les Maîtres de l'Affiche in the right corner. It has been cut
 along the lower edge so that the printed stamp of the
 Imprimerie Chaix on the left is missing
306 × 221 mm (image), 337 × 236 mm (colour plate),
 370 × 291 mm (sheet size)
Provenance: Unknown
Literature: E. Crauzat *L'Oeuvre gravé de Steinlen* Paris, 1913,
 No. 217

This print was issued in March 1898 with No. 28 of Les Maîtres
d'Affiches. This was a monthly publication operated by the art
critic Roger Marx which appeared from 1895–1900. Its purpose
was to celebrate modern achievements in colour lithography by
reproducing current posters and major recent works in small-
scale colour lithographs; four reproductions were issued each
month. This example is signed by the artist, and may have been
part of a special edition.

One of Steinlen's favourite themes was that of Parisian
streetlife, seen mainly in terms of working class pleasures and
hardships. His lithographs – skilful, even virtuoso in their
draughtsmanship – often show nocturnal scenes with lights,
reflections, and figures caught in a glare or emerging from the
gloom. Here the beige colour plate acts as a middle tone; it
functions as shadow in the window and on the band-box, as
flesh-colour (while the blank paper carries the brightest
highlights) and it allows great variation in the tonal range of the
black crayon. Young, pretty milliners or errand-girls are recurring
types in Steinlen's prints, while the theme of the tempting,
unaffordable window-display can be treated with sentiment, as
here, or with a stronger moral message as when undernourished
street urchins gaze at food, or prowling lechers try to pick up girls
who stare wistfully in windows.

55 Théophile-Alexandre Steinlen

Ouvriers sortant de l'usine (Workers leaving the mine)
Crayon lithograph in black ink on Holland paper. Signed on the
 plate *Steinlen* lower right. Signed by the artist in pencil
 beneath, and inscribed lower left in pencil with the title
215 × 302 mm (plate), 250 × 326 mm (sheet size)
Provenance: Purchased in London from Mr. Lewin, £3
Literature: E. Crauzat *L'Oeuvre gravé de Steinlen* Paris, 1913,
 No. 254, reproduced p. 85

This is a proof of the print which was published in *Representative
Art of Our Time* by the Studio Library in May 1903. The
lithography section consisted of this print; a colour lithograph,
Brume Matinele, by Henri Rivière; Brangwyn's *The Mine* (No. 5
above) and *A Study (Boy with a Bull)* after a drawing by H.H. La
Thangue. Steinlen was one of the best known French artists of
the day in England. This image is an essay in black, a beautifully
worked tonal study in the manner of a conté crayon drawing
where the blank paper emerges only for the brightest areas. Like
Brangwyn, Steinlen often portrayed physical labour and its
hardships – the theme of mineworkers most notably in his
lithographic cover and illustrations for Emile Morel's *Les Gueules
noires* of 1907.

56 Henri de Toulouse-Lautrec (1864–1901)
 La Goulue (Louise Weber)
Pencil on faded buff paper; some of the contours incised.
 Red stamp with Toulouse-Lautrec monogram lower left.
 Some old glue stains lower corners
151 × 93 mm (inside of aperture)
Provenance: From the collection of Tapié de Celeyran; sold
 Gutekunst and Klipstein; purchased Michel, Paris 1958
Exhibitions: Ingelheim 1968, No. 77
Literature: Dortu D 3.311

This striking character study of the poised, disdainful, fashionably dressed La Goulue may be connected with a lithograph published in 1894 (Wittrock 65). La Goulue (Greedy Gut) was the nickname of Louise Weber, a dancer who became the star attraction at the Moulin Rouge; she was to die destitute in 1929. In the lithograph she is shown waltzing with a popular male dancer, Jacques Renaudin, known as Valentin-le-Désossé (Boneless Valentine); her costume is similar but she has lost her exotic hat, while her body is held at a different angle. La Goulue had already appeared in Toulouse-Lautrec's work in his first poster, for the Moulin Rouge in 1891 (W.P1), and again in the lithograph *Au Moulin Rouge* of 1892 (W.1).

The drawing was quite likely made around 1892 as Dortu suggests. The main contours, especially the profile and the line of the neck, are incised as though traced over: Toulouse-Lautrec often used tracings to transfer and develop images. The study may have been made from life, or worked up from a quick sketch. The artist's absorption of Japanese modes of composition is apparent in the precise, neat drawing of features, the attention to hairstyle (appropriately as La Goulue's upswept red hair was her hallmark), and, an echo of the Japanese conventional depiction of courtesans, the view from the back with the shoulders emphasised.

Dr. Gabriel Tapié de Celeyran, who owned this drawing, was a cousin and close friend of the artist: he was very tall, and Toulouse-Lautrec enjoyed the stir they created when they went about together.

57 Henri de Toulouse-Lautrec
Deux femmes (Two women)
Pen and brown ink on faded buff paper. Laid down
172 × 109 mm
Provenance: Paris, Hôtel Druout 9th and 10th July 1947,
 succ. Bunau-Varilla No. 9; M. Raykis; sold Stuttgart
 26th November 1952, No. 1.148; Dr. R. Mohreuwitz,
 Zurich; Sotheby's Sale 30th April and 1st May 1969,
 Lot 280
Literature: Dortu 3.455

This free, economical sketch of a tight-lipped, buttoned-up
woman – she wears a high collar, her hair is stiffly upswept and
her pillbox hat has a thin feather aloft – with a rather leering,
soft-hatted companion provides just the sort of contrast
Toulouse-Lautrec's sharp wit would record in his observation of
the demi-monde. The drawing was a preliminary study for a
lithograph published by l'Escaramouche in the 12th November
1893 issue, and entitled *Pourquoi pas? . . . Une fois n'est pas
coutume* (Why not? . . . Once won't start a habit), where the
women and a bearded man-about-town size each other up
(Wittrock 30). By the end of 1893 Toulouse-Lautrec no longer
made preparatory drawings for lithographs but drew directly on
the stone, something which required great confidence and
concentration, owing to the great difficulty of making
corrections.

58 Henri de Toulouse-Lautrec
Portrait of Henri Rochefort Luçay
Pen and brownish-black ink on cream paper, faded. The stamp
 T.N-H.TL lower right (Lugt Suppl. 2449a)
187 × 308 mm
Provenance: Mme. Thadée Natanson, Paris, Sale
 27th November 1953, No. 30; Sotheby's Sale
 3rd December 1958, Lot 34, £150
Exhibitions: Ingelheim 1968, No. 35
Literature: Dortu D 3.702; T. Natanson *Un H. de Toulouse-*
 Lautrec Geneva. 1952 p. 39 reproduced as an untitled
 croquis.

Henri Rochefort Luçay (1830–1913) was a famous journalist and
political activist. Lautrec's wonderfully calligraphic sketch
captures in a variety of curving shorthand strokes a likeness
which is closer to a decorative vignette than to a cartoon. Dortu
dates this drawing to around 1894. Sickert also portrayed
Rochfort in pen and ink, like Toulouse-Lautrec emphasising the
man's wiry cockade of hair (Witt Library 4240). (Over a decade
earlier, Manet painted his portrait, now in the Kunsthalle,
Hamburg, and at the same time, 1880–1, had been inspired to
paint *The Escape of Rochefort* recording his dramatic flight from
prison in 1874, now in the Kunsthalle, Zurich.)

Thadée Natanson was with his two brothers a founder of *La
Revue Blanche* in 1891; it was an intellectual magazine, a
showcase for new literary and artistic talent. Felix Fénéon, art
critic and admirer of Seurat and Signac, was its director. The
Natansons were friends and patrons of artists and writers
including Proust, Mallarmé, Vallotton, Bonnard and Toulouse-
Lautrec, who portrayed Misia Natanson in a poster of 1895
advertising the magazine (Wittrock P16) and on a cover for
L'Estampe Original of the same year (W.86).

59 Henri de Toulouse-Lautrec
　　Les Valseuses (The waltzers)
Blue and red crayon on thick cream paper
350 × 224 mm
Provenance: Sotheby's Sale 25th November 1964, Lot 122,
　　£1950
Literature: Dortu 3.731
Colour plate p. 25

Toulouse-Lautrec was fascinated by behind-the-scenes life in brothels, by the domestic routine, the intimacies between the women, the washing, dressing, doing of hair – he is known to have rented a room and lived in a brothel so as to be able to sketch whenever he liked. His lithographic series *Elles* was on the theme of the lesbian relationship of two women in a brothel (Wittrock 155-65).

This amusing sketch of an uninhibited moment shows two women in their slips and stockings dancing – one tall and severe, reminiscent of the figure in No. 57, the other plump and animated, drawn with more broken contours suggesting mobility and gusts of laughter. The artist may have begun with the blue crayon and then continued with the red, highlighting the expressive features of mouth and chin and drawing most of the bodies and background with the warmer tone.

Dortu suggests a dating of around 1894 for this drawing. The motif of two women waltzing occurs in a lithograph of 1897, *Danse au Moulin Rouge* (W. 181) but the mood of this drawing is entirely different.

60 Henri de Toulouse-Lautrec
 Tête de femme à la chevelure defaite (Head of a woman
 with untidy hair)
Dark blue crayon, rubbed at the centre, on buff paper.
 Monogram in violet (faded) lower left
146 × 232 mm
Provenance: Charles Vignier; Paris, Vente Vignier, 21st May
 1931, No. 125; Maurice Exsteens; M. Knoedler from
 whom purchased 1956, £280
Exhibitions: Basle, Kunsthalle, 1947 *Toulouse-Lautrec* No. 119;
 Amsterdam, Stedelijk Museum and Brussels, Palais des
 Beaux-Arts, 1947 *Toulouse-Lautrec* No. 95; Ingelheim
 1968, No. 21
Literature: M. Delaroche-Vernet Henraux *Henri de Toulouse-
 Lautrec Dessinateur* Paris, 1948, pl. 13; P. H. Huisman and
 M. G. Dortu *Lautrec par Lautrec* Paris, 1964, repr. p. 124 in
 a sanguine ink; Dortu D 4.043
Colour plate p. 31

Gaiety is successfully captured in this expressive head, where the
rubbing of the crayon gives a blurred effect suggesting shadow
and movement, as though drawn in a split-second. The woman's
strong features and snub nose quite possibly are those of the
model in two other blue crayon drawings (Dortu 3.480 and
4.049). This drawing is one of many quick studies of women in
brothels (where Toulouse-Lautrec spent much of his time)
sketched from life, and probably dates from 1894–5.

61 Henri de Toulouse-Lautrec
Yvette Guilbert
Crayon and spatter lithograph in olive-green ink on Velin d'Arches paper
290 × 138 mm (image), 381 × 315 mm (sheet size)
Provenance: Purchased from the O'Hana Gallery, London, May 1954, £12
Literature: Wittrock No. 78; Delteil No. 88
Colour plate p. 24

This is a rare proof before the addition of letters to the ninth plate of the album *Yvette Guilbert* which was published in 1894 by André Marty of *L'Estampe Original*. The album contained a lithographic cover-title and sixteen plates with an essay by the critic Gustave Geoffroy celebrating the famous café-concert singer Yvette Guilbert (who signed each of the 100 printed copies of the album). In fact Geoffroy's text pins great ideological and even political weight on the figure of Yvette Guilbert, whereas Toulouse-Lautrec's entrancing images are wholly concerned with her personality as a performer. Guilbert (1865–1944) began as an actress, but turned to singing in 1887; by

1890 at the popular café Le Divan Japonaise she had perfected an unforgettable style of dress and performance – long black gloves and a plunging neckline emphasising a bony, almost gaunt figure. Toulouse-Lautrec sketched her during her shows, and in the album evokes a full performance up to her final curtain-call.

Yvette first appeared in Toulouse-Lautrec's work in a poster of 1892 advertizing the Divan Japonaise; in 1893 she was his subject in one of his 11 lithographs of performers in *Le Café Concert* (Wittrock 19), another of André Marty's *L'Estampe Original* publications. A further lithograph of 1894 showed her in *Colombine à Pierrot* (W.68) while in 1898 W.S. Sands commissioned the 'English Series' of nine lithographs of Yvette in concert (W.271-9).

Toulouse-Lautrec used a spatter technique (*crachis*) where a rain of ink from a stiff brush on the stone could evoke a variety of effects – the technique had long been used by poster artists like Jules Cheret. Here the spots of ink suggest a spangled theatrical atmosphere of shifting lights, curtains, smoke and the aura of the star herself.

62 Henri de Toulouse-Lautrec
Eros vanné (Cupid exhausted)
Crayon lithograph in black ink on white paper. The monogram
 stamp in black lower left. Near the lower right corner of
 the sheet, *Eros vanné* inscribed in pencil
290 × 220 mm (image), 492 × 331 mm (sheet size)
Provenance: Purchased from Klipstein, Berne, 1954, £18
Exhibitions: Ingelheim 1968, No. 81; Jerusalem,. Israel Museum
 1967, *Henri de Toulouse-Lautrec prints from the F.M. Gross
 Collection* No. 23
Literature: Wittrock No. 56; Delteil No. 74

This image was first drawn as here, and printed only in a few
proofs. It was then published as a song sheet in 1894 with the
image transferred to further stones and reduced in size, and the
words of a monologue written by Maurice Donnay and sung by
Yvette Guilbert (see No. 61) regarding the trials of the young
Eros. A second edition was issued before 1910 with the original
full-size image. Toulouse-Lautrec's sense of humour and his lynx-
eyed observation of a particular slice of society are again in
evidence in this group of a sadly battered and disgruntled Cupid
viewed with world-weary amusement or indifference by two
women at the bar of a café. 'Eros vanné' according to Donnay
presided over Sapphic or lesbian affairs amongst other duties
and the theme of lesbianism occurs elsewhere in Toulouse-
Lautrec's work. The artist enjoys the exaggerations of fashion (or
streetwise inventiveness) and here one woman wears a mannish
hat and greatcoat at odds with her fur boa, while the other is
more outlandish in a high stiff collar and an elaborate wiry hat.

A preparatory drawing in pen and ink for this lithograph is
also in the Fritz Gross Collection (Dortu 3.664).

63 Henri de Toulouse-Lautrec

Souper à Londres (Supper in London)

Crayon lithograph in grey ink on beige wove paper. Signed in pencil lower left *T. Lautrec.* Top right, inscribed *65* (underlined)

312 × 362 mm (image), 345 × 475 mm (sheet size)

Provenance: Purchased from Ackermann and Sauerwein, Munich, August 1965

Exhibitions: Jerusalem, Israel Museum 1967, *Henri de Toulouse-Lautrec prints from the F.M. Gross Collection* No. 44

Literature: Wittrock No. 169; Delteil No. 167

This lithograph was published in one edition only of 100 impressions in 1896 by *Le Livre Vert,* another of André Marty's ventures (see also No. 64), as part of the series *Études de Femmes.* This consisted of twelve prints in four instalments, including work by Jules Cheret, Puvis de Chavannes, Steinlen and Vallotton. Marty had encouraged Toulouse-Lautrec to produce small-scale prints for the collector as well as poster designs; he was a major print publisher who fostered and catered for the new taste of the 1890s for original artists' prints, less expensive than paintings to frame and hang on the wall.

Here Toulouse-Lautrec conjures up the mores of a social world and the nuances of a particular encounter. The woman is the main protagonist; she is admired by her escort, himself half-obscured by the absurdly enormous puffed sleeves of her evening dress, while a waiter behind seems equally mesmerized. She is a typical demi-mondaine, extravagantly dressed, sparkling among jewels and champagne, sharp-chinned and vivacious. The lavishly piled salver on the left is drawn with extraordinary freedom.

64 Felix Vallotton (1865–1925)
 Le Chapeau vert (The green hat)
Crayon lithograph in black ink on white card. The monogram is
 on a hatbox lower left
388 × 265 mm (image), 457 × 338 mm (sheet size)
Provenance: Purchased from the Galerie Paul Vallotton,
 Lausanne, August 1969
Literature: L. Godefroy *L'Oeuvre gravé de Felix Vallotton* Paris
 and Lausanne 1932, No. 53; C. Goerg and M. Vallotton
 Felix Vallotton Geneva, 1972, No. 54

This is a proof of the black crayon plate only of the lithograph
which was issued as part of the series *Études de Femmes* in 1896
by André Marty's *Le Livre Vert* (see also No. 63). Vallotton used
black lithographic chalk for the main subject, for the outlines of
the woman's hat and for the word 'modes' printed in reverse. He
then brushed on with lithographic ink the pale ochre stripes of
the awning of the shop and the green details of the hat, so that

the lithograph was actually published in three colours.
Vallotton's sensitivity to tone is seen here in the way in which the
dark-clad body of the milliner, and especially her shadowed face,
stand out against the equally dark curtain behind her.

Trained as a painter, Vallotton turned to etching and
engraving as a source of income during the 1880s and produced
illustrations on commission for dealers and art magazines. By the
end of the decade he was printing his own designs and his
woodcuts in particular were hailed as exciting innovations in
original printmaking. Thadée Natanson wrote in *La Revue
Blanche* that Vallotton had regenerated the art, while the
German art critic Julius Meier-Graefe published a catalogue of
his woodcuts as early as 1898. Vallotton's work influenced artists
as diverse as Beardsley and Munch. While his lithographs are not
generally perceived as being as important as his woodcuts,
nevertheless his experiments with colour lithography are
comparable with those of Toulouse-Lautrec.

Catalogue of works by Fritz Gross

65 Self portrait
Lithographic chalk on cream paper
23 × 18.3 cm
Signed and dated *F. Gross 1915* in pencil
lower right

This self-portrait, made at the age of twenty,
was originally mounted to show the head
only, hence the pencil markings. Inscribed on
the mount in pencil is *Lithags. Studie fur
einem Selbstbieldnis* and *Fritz Gross/Wien
1915*. (Lithographic [chalk] study for a self
portrait). Also on the mount is a dedication
of the drawing to the artist's sister,
dated 5 March 1918.

66 Head of a bearded man
Lithographic chalk on ivory-coloured paper
48 × 44.3 cm (irregular)
Signed and dated *Gr 20* top right in pencil
Exhibited in Vienna, Galerie Peithner-
Lichtenfels, 1982, No. 31

The sitter for this forceful portrait is not
known, but the intimacy of observation
makes it likely that the model was well
known to the artist. The oily surface of the
lithographic chalk has been scored with a
fine implement to give greater highlights and
thus greater plasticity to the image.

67 Woman with upturned head
Charcoal on faded white paper
42 × 30 cm
Signed and dated *Gr '21* lower left

This charcoal drawing was made from life in
1921, probably of a friend of the artist.

68 On the harbour, Marseilles
Colour lithograph in black, grey, brown,
deep blue and yellow ochre on buff paper
40 × 30 cm

This colour lithograph is a leaf from a
Viennese magazine. The text printed beneath
the plate reads in translation: 'Fritz Gross, On
the harbour, Marseilles. Original lithograph.
Published by the Society for the
Reproduction of Art. Printed by "Secession"
GmbH Vienna'. Years later, the subject
matter and composition of this image served
as a model for the first lithograph the artist
made on his own lithographic press.

69 At the window
Etching in black ink on cream paper with corrections in pencil
18 × 16.4 cm
Studio stamp lower right below plate

The etching was based on a drawing made in 1936. It shows the sensitive handling of the female nude which runs as a thread throughout Fritz Gross's work.

70 Franzi, the artist's wife
Pastel on buff cardboard
46 × 38 cm
Signed lower right in pastel: *for Franzi/Fritz Gross/1942*

The sideways set of the head and penetrating glance captures well the personality of Franzi Gross. Many other artists attempted to catch the finely chiselled and elusive features of the artist's wife without success.

71 String musicians
Red chalk with touches of white on buff-coloured paper
39.5 × 32.9 cm
Studio stamp on bottom right. Circa 1942

During the Second World War whilst Fritz Gross was head of the art department of the Bedford School, the BBC Symphony Orchestra was evacuated to Bedford, where it gave concerts in the Corn Exchange Hall. These concerts were broadcast to the nation. Often during rehearsals the artist used to draw the musicians being conducted by Sir Henry Wood or Sir John Barbirolli.

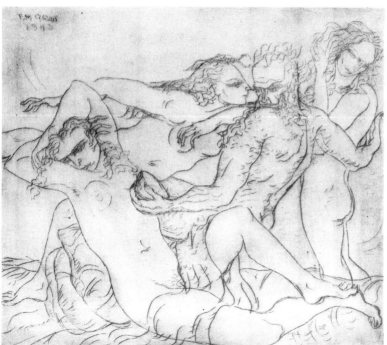

72 Lot and his daughters
Etching in black ink on a thin Japan-type paper
23 × 26.4 cm
Signed top left on the plate: *F.M. Gross/1943*
Inscribed in orange crayon lower left: *3/6*
Inscribed on the right: *Lot and his daughters Gr*

The artist was intrigued by this subject and several drawings exist of Lot with his daughters. This etching is almost balletic in movement with a tightly knit solidity of composition.

73 Nude drying her hair
Gouache on paper laid on board
Irregularly shaped paper, 60.5 × 55 cm
Signed lower left *F.M. Gross/1943*

Fritz Gross used gouache rather as he
handled oil. The emphasis is on the outlines
of the form and on the different textures and
the highlights of the flesh tones. The artist
was always as concerned with the depiction
of colour as he was with the rendering of the
nude female form.

74 Two young friends
Pastel on board
45 × 39 cm
Signed: *F.M. Gross* (date obscured, circa
1943)
Colour plate p. 39

Pastel was a medium favoured by Fritz Gross
as it enabled him to express brilliance of
colour and the accentuation of light against
dark tones.

75 Portrait of Gwilym Morgan
Etching in black ink on cream paper
23 × 18 cm
Signed lower left on the plate *Gross/1944*
and inscribed in pencil lower right, *Gross/44.*
Inscribed on the lower edge with the title and
3rd état

This is one of a series of portraits made of
Gwilym Morgan, a sculptor and close friend
of the artist.

76 Artist's mother
Lithographic chalk on paper
33 × 23.6 cm
Inscribed by the artist lower left in
lithographic chalk *30 Sept 1944;* signed with
initials *Gr./1944*

A vigorously drawn portrait and strong
likeness of the artist's mother, Mathilde
Gross, made with an unwavering sureness
of line.

77 Whispering lovers
Etching in black ink on thin Japan-type paper
Sheet: 26 × 19.7 cm
Plate: 17.1 × 15.6 cm
Numbered left under the plate mark *4/10*
in pencil; studio stamp lower right. Dated
circa 1945

Pulled by the artist on his own press.
'Harlequins' and 'Clowns' were subjects to
which Gross returned many times. See also
No. 83, and 91.

78 Artist's daughter and cat
Charcoal highlighted with white chalk on
buff paper
45 × 38 cm
Signed lower right *Gross/1946*

A rare depiction of the artist's daughter since
she was an impatient and unwilling model.

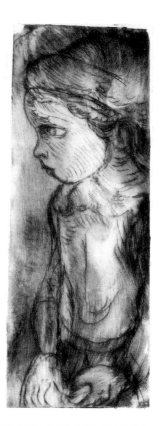

79 Immigrant child

Etching in black ink on thin Japan-type paper
Sheet size: 22.1 × 15.1 cm
Plate size (irregular): 14.5 × 5.5 cm
Inscribed in crayon with the letters *Gr* in the
lower right corner in the artist's hand

This etching was produced in 1946 by the
artist on his own etching press (and it shows
his fingerprints). The subject was inspired by
scenes of displaced war orphans.

80 Girl with accordion

Oil on canvas
76 × 63 cm
Signed *F.M. Gross/1947* top right
Colour plate p. 38

The artist's predilection for red hair
prompted the painting of this picture, which
took many years to complete. It underwent
various changes of model, as well as the re-
positioning of both hands and accordion.

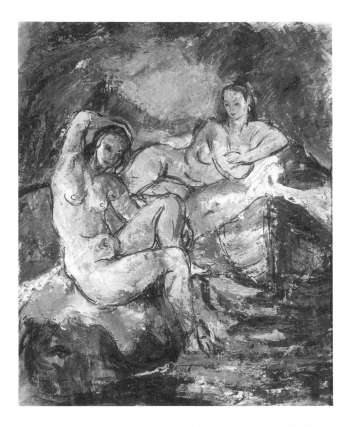

81 Two nudes in a rowing boat
Gouache on paper
38 × 31.5 cm

The subject-matter of this attractive picture
reflects the artist's great admiration for
Renoir. The medium, although gouache, is
handled more like oil.

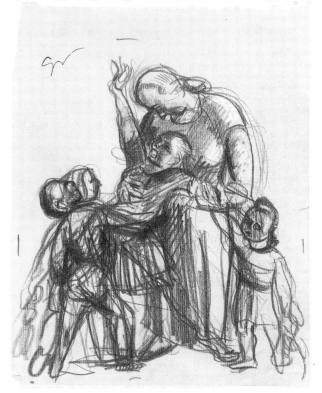

82 Mother and children
Mixed media on blue paper, predominantly
pencil heightened with red and white chalk
22.9 × 17.7 cm
Signed with initials *Gr* in ink top left

This drawing does not appear to be related
to any finished picture. The artist seems to be
working on an idea for an ambitious project,
given the cohesive composition of the
ensemble. Fritz Gross often made sketches
for sculptural decorations for his architectural
designs, which were executed by sculptors
like Jacob Löw, Georg Ehrlich and Trevor
Tennant. This may have been a preliminary
idea for such a design.

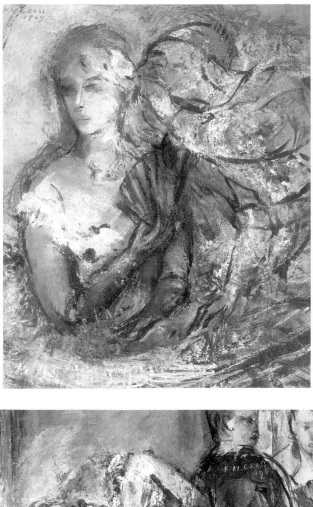

83 Harlequin whispering to girl
Pastel with touches of black ink on buff-
coloured paper
29 × 23 cm
Signed *F.M. Gross/1949* top left
Exhibited Vienna, Galerie Peithner-
Lichtenfels 1982, No. 23

84 At the theatre
Oil on canvas
34 × 29 cm
F.M. Gross/49 scratched top right into the
dark coat of the standing young man in the
background

The theme of the young attractive woman
juxtaposed with the maturer matron, and the
undercurrents of emotional tensions created
thereby, was a subject to which the artist
often returned.

85 Girl with hand on lip
Oil on stiff board
27.5 × 24 cm
Signed bottom right: *Gross '49*

Many years of re-working and subtle
changes brought this picture to its final
highly modelled state.

86 Seated nude
Pastel on faded white paper
37.3 × 24.5 cm
Studio stamp bottom right. Undated

Delicately wrought using sparing pastel
colours, this drawing presents a nude girl in
reverie.

87 Nude seen from behind
Pastel on grey paper
34.7 × 23.5 cm
Signed with initials *Gr* and dated 1950 in
pencil top right

A slight underlay of gouache emphasises the
body contours. This drawing exemplifies the
easy proficiency with which Fritz Gross
handles the medium of pastel.

88 Paris café II
Lithograph in black ink on white paper
50.9 × 32.3 cm
Signed on the stone, right: *Paris/Gr 51.*
Inscribed *1/7* in pencil lower left

In his latter years — and no doubt under the
influence of Henri de Toulouse-Lautrec's
genius with the medium of lithography —
Gross acquired and experimented with his
own lithographic press. The ease with which
he could express himself in drawing afforded
the opportunity to record lively scenes
observed with humour, such as this example
seen on a Parisian boulevard.

89 Chefs producing

Drypoint in greenish-black ink on cream paper

8.5 × 13.1 cm

Inscribed on the plate: *F.M. Gross/57/A/ HAPPY CHRISTMAS TO YOU/AND HAVE A/ GOOD TIME*. Inscribed beneath the plate, lower left, by the artist: *Orig. drypoint 4/40;* signed lower right *F.M. Gross/57*

For some years Gross designed and produced his own Christmas cards. His friends received this one in 1957.

90 Girls lunching

Lithograph in dark green ink on linen fibre paper

19 × 23 cm

Signed on the stone lower right: *F.M. Gross/59*

Designed as a Christmas card by Fritz Gross in the year 1959.

91 Two clown musicians
Charcoal on white paper
27 × 18.2 cm
Signed and dated *GR/59* lower right

The theme of musicians and also of clowns always fascinated Fritz Gross. The two subjects are combined in this comical sketch.

92 Seated girl, side view
Sepia chalk on paper
50.8 × 39.5 cm
Signed with initials *Gr* and dated 1960 lower left

93 Mother and child
Pastel and ink on paper
20 × 13.7 cm
Signed with initials *Gr. 60* in black ink lower right

A preliminary study for the painting No. 94 in this exhibition. The age, turn of the head and attitude of the child in this drawing are not quite the same as in the oil painting.

94 Mother and child
Oil on canvas
55 × 45 cm
No signature
Colour plate p. 38

Despite its unfinished appearance in parts, this stylized and simplified composition displays a highly sophisticated use of the oil medium. A preparatory study for this painting is shown in No. 93.

95 Three figures
Mixed media: pastel, ink and gouache on faded white paper
42.4 × 27.8 cm
Studio stamp lower left

Human relationships – love, jealousy, sadness – are all depicted in a symbolic triangle. The mixture of ink, gouache and pastel is used in an unconventional way.

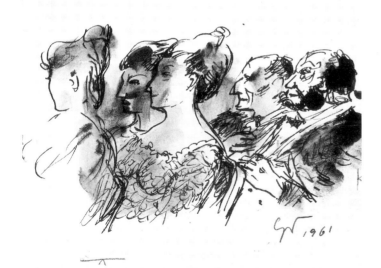

96 Audience
Pen, ink and wash on buff paper
19.5 × 14.8 cm
Signed and dated *Gr 1961* in blue ink lower right

A quick character sketch of an audience dressed for an evening of serious music. Fritz Gross always sought to draw expressions caught at off-guard moments.

97 Nudes on the beach
Etching in brown ink with corrections in
pencil on buff coloured paper
23.3 × 23.5 cm
Signed lower right below platemark with
initials *Gr.* in felt-tip pen and on the left the
word *proof*

Proof print hand-pulled by the artist on his
own etching press, with soft-leaded pencil
additions.

98 Mother and child from behind
Pen, ink and wash on buff paper
25.5 × 22.4 cm
Studio stamp lower right

This sketch of mother and child, briefly
observed, was done on the fly-leaf of a
catalogue, showing the artist's compulsion
for drawing even though conventional
drawing paper was not to hand at the time.

99 Woman with a towel
Pastel on faded white paper
42.5 × 27.8 cm
Studio stamp lower right

100 Two girls
Etching in black ink on Japan-type paper
Sheet size: 26.6 × 22.2 cm
Plate size: 22.8 × 16 cm
Faint studio stamp lower right inside the
plate mark

Etching printed by the artist in his studio on
his own etching press.

101 Girl bathing her legs
Pastel on buff-coloured paper
42.5 × 28 cm
Marked with studio stamp lower left

102 Old Menton I
Lithograph in a greenish-black ink on white paper
40.6 × 29.4 cm
Inscribed on the stone lower left *F.M.Gr./Menton/Feb. 1967.* Inscribed by the artist in pencil lower left, beneath the plate: *3/4 orig. lithograph;* and lower right *F.M. Gross*

Fritz Gross's architectural background is clearly seen here. A few sensitively placed lines bring the houses and the busy two-tiered road to life. This lithograph was pulled by the artist on his own lithographic press.

103 Cap Martin
Pastel on paper
62.2 × 46.9 cm
Signed in pencil by the artist lower left, *F.M. Gross 1967,* and inscribed by him lower right *Cap Martin*
Colour plate p. 39

This is one of a number of landscape pastels which the artist made in Cap Martin in the south of France towards the end of his life.

104 Madame Dortu
Etching in reddish-brown ink on buff paper
23 × 10.5 cm
Signed on plate *F.M. Gross/Ingelheim '68*

This etching of Madame Dortu was made from a portrait sketch from life. Fritz Gross met this eminent authority on the work of Henri de Toulouse-Lautrec on the occasion of an exhibition of pictures by Lautrec held in Ingelheim, West Germany, to which Gross loaned many works from his own collection (see above No. 56, 58, 62). The brilliance of Lautrec's drawing provided a lasting influence on Fritz Gross's own creativity.

Acknowledgements

I should like to thank the following people for their generous assistance in the preparation of catalogue entries for the works of art in the Fritz Gross Collection: Juliet Bareau, Dr. Wendy Baron, Dr. Petra ten-Doesschate Chu, Dr. Arne Eggum, M. Jean-Jacques Fernier, Renate Gross, Dr. John House, Christopher Lloyd, Dr. Nicholas Penny, Dr. Richard Thomson, Anne Thorold, and Linda Whiteley.

Dr. Catherine Whistler
Ashmolean Museum

List of artists represented in the exhibition

Beardsley, Aubrey 1
Bonnard, Pierre 2, 3
Boudin, Eugène 4
Brangwyn, Frank 5
Cézanne, Paul 6
Chagall, Marc 7
Courbet, Gustave 8
Cross, Henri-Edmond 9
Daumier, Honoré 10, 11, 12
Degas, Edgar 13
Derain, André 14, 15
Forain, Jean-Louis 16, 17
Gauguin, Paul 18, 19, 20, 21, 22, 23
Gonzales, Eva 24
Gross, Fritz Max 65 – 105
Liebermann, Max 25
Maillol, Aristide 26
Manet, Edouard 27, 28
Modigliani, Amedeo 29, 30
Morisot, Berthe 31
Munch, Edvard 32
Pascin, Jules 33
Picasso, Pablo 34, 35, 36, 37
Pissarro, Camille 38, 39, 40
Renoir, Pierre-Auguste 41, 42, 43
Rodin, Auguste 44
Rouault, Georges 45
Seurat, Georges 46
Sickert, Walter Richard 47, 48, 49
Signac, Paul 50, 51
Sisley, Alfred 52
Steinlen, Théophile-Alexandre 53, 54, 55
Toulouse-Lautrec, Henri de 56, 57, 58, 59, 60 61, 62, 63
Vallotton, Felix 64